WEST VIRGINIA
WONDER AND LIGHT

Photography by

Ian J. Plant

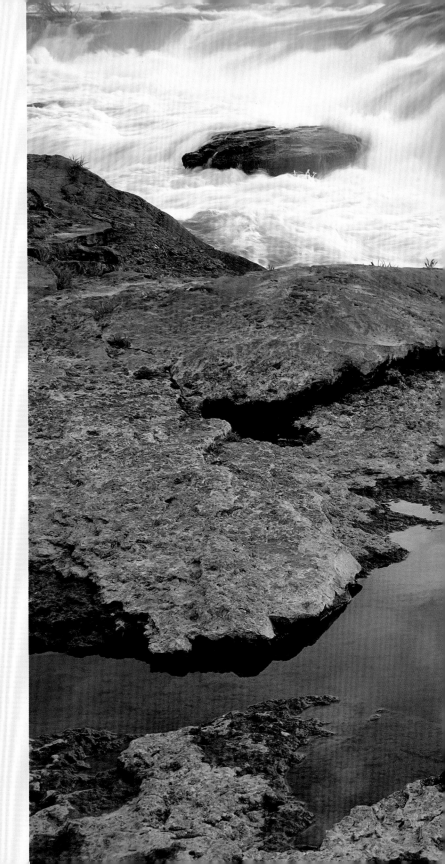

WEST VIRGINIA
WONDER AND LIGHT

Photography by
Ian J. Plant

Mountain Trail Press

1818 Presswood Road • Johnson City, Tennessee 37604
www.mountaintrailpress.com

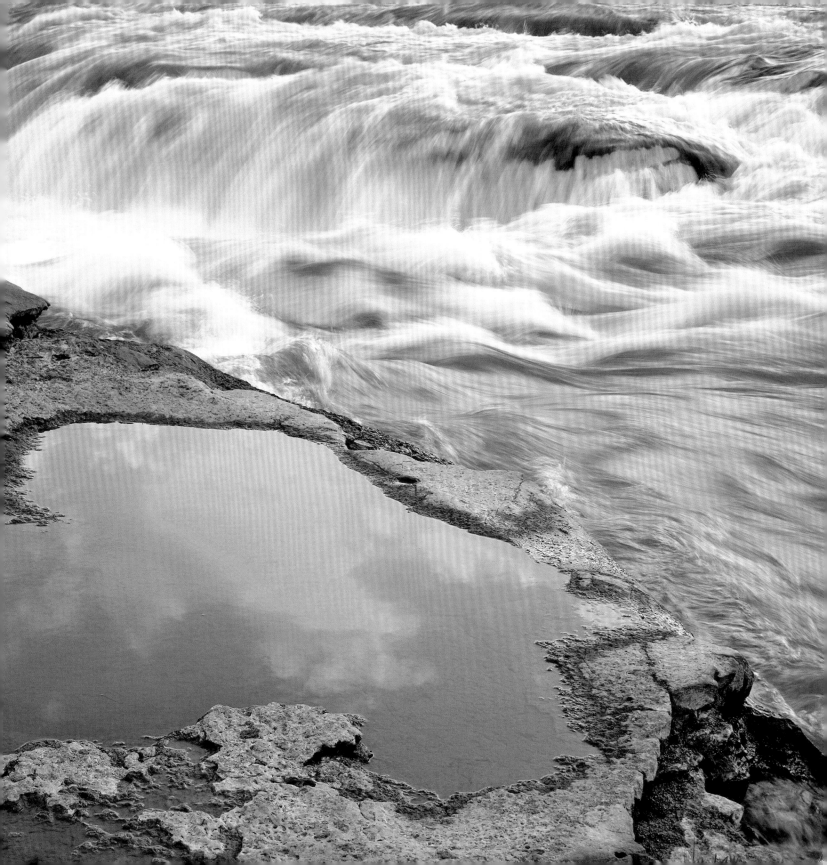

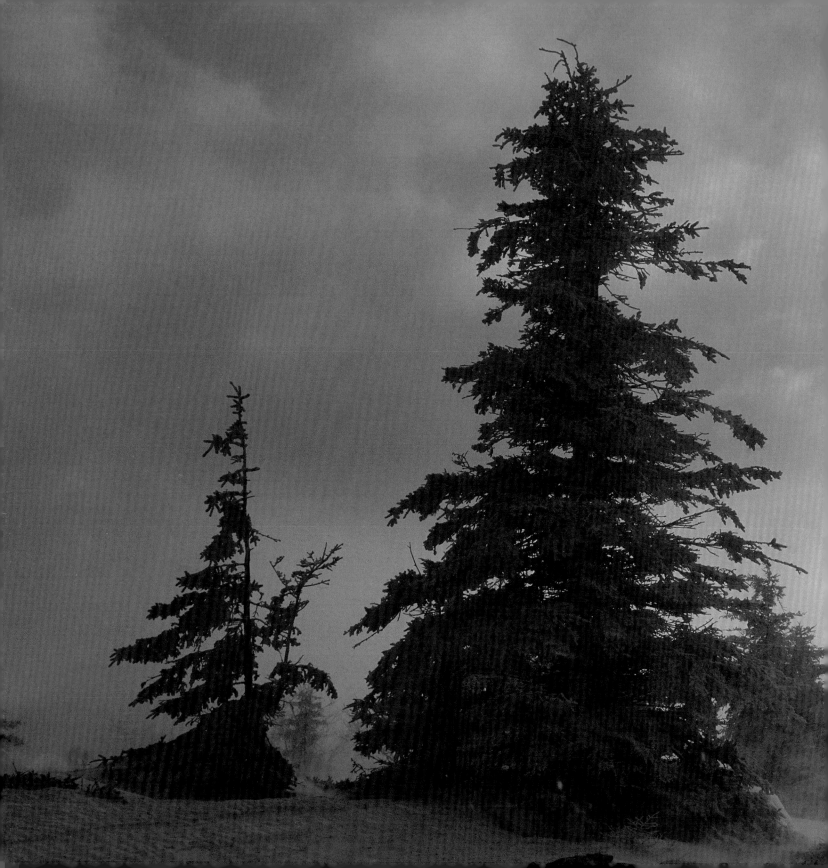

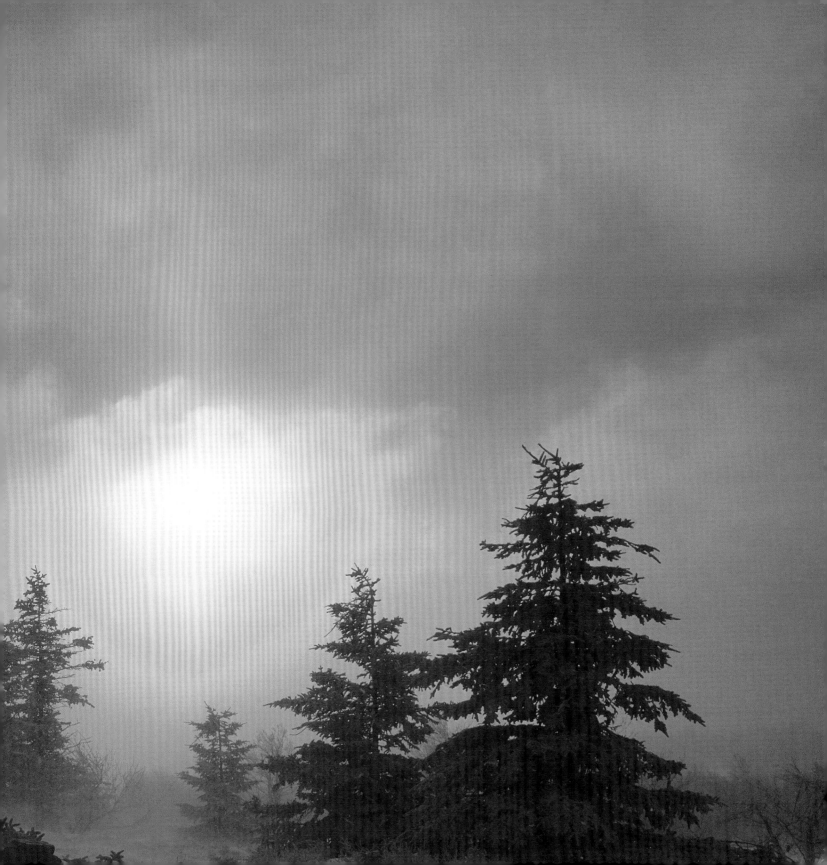

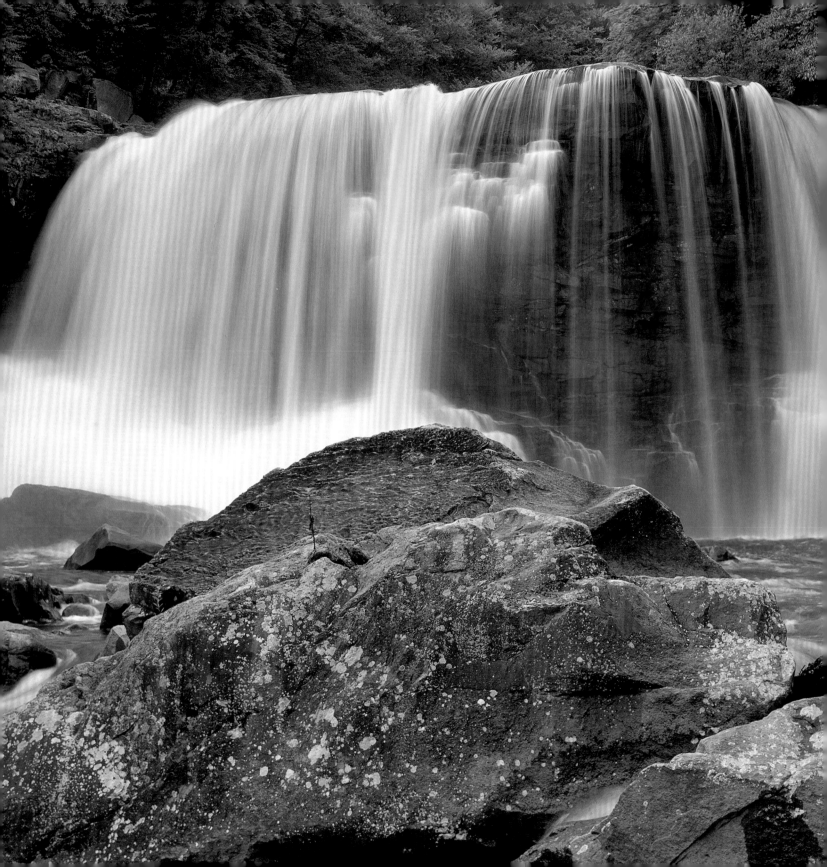

WEST VIRGINIA
WONDER AND LIGHT

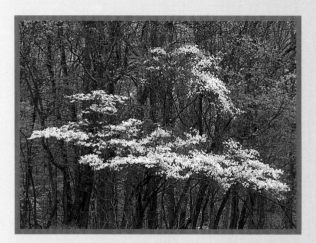

Ian J. Plant

Book design: Ian J. Plant
Editor: Jerry Greer
Entire Contents Copyright © 2005 Mountain Trail Press LLC
Photographs © Ian J. Plant 2005
All Rights Reserved
No part of this book may be reproduced in any form without written permission from the publisher.
Published by Mountain Trail Press LLC.
1818 Presswood Road
Johnson City, TN 37604
ISBN: 0-9770808-0-3
Printed in Korea
First Printing, Summer 2005

Front cover: Alpenglow paints the cliffs of North Fork Mountain with the pink and red hues of sunset

Title page (frontpiece): Violets and woodland sunflower, blooming along the Greenbrier River Trail

Title page (background): False hellebore grows in profusion along the Highland Scenic Drive

Second title page: Sunset reflects in slickrock pools below Sandstone Falls, New River Gorge National River

Preceding page: Winter light, Dolly Sods

Left: Tannin-stained waters of Blackwater Falls

Above: Dogwood blooms in the George Washington National Forest

INTRODUCTION

West Virginia is a magical place. From windswept mountain plains to deep-forested canyons, West Virginia possesses a diversity of landscapes that is unique and wonderful. Known as "Almost Heaven" by the locals, after spending years exploring and photographing West Virginia I cannot help but wonder whether the "almost" can be dispensed with altogether. The variety of landscapes in the state is stunning.

West Virginia is dominated by mountains. With most of the state on the Allegheny Plateau, West Virginia has the highest mean altitude of any state east of the Mississippi. The eastern escarpment of the Plateau, known as the Allegheny Front, contains some of the most dramatic mountain scenery in the Eastern United States. On one side of the Potomac River valley, soaring cliffs rise at Seneca Rocks and North Fork Mountain. On the other side dramatic peaks rise, including mighty Spruce Knob Mountain (West Virginia's highest) and the high mountain plateaus of Dolly Sods and Roaring Plains. Travel south along the Highlands Scenic Drive, and the high mountains continue their seemingly unending march.

West Virginia's mighty rivers cut deeply into the mountainous terrain. The Blackwater River has carved a canyon 600 feet deep; not to be outdone, the New River has carved 900 feet out of the southern Alleghenies. Canyons are not the only geologic feature that result when mountains and water collide – West Virginia is also replete with majestic waterfalls. Once again, the New and the Blackwater rivers offer much in this regard – with Sandstone Falls on the New being the widest waterfall in the state, and Blackwater Falls the tallest – but many other less dramatic though no less beautiful falls can be found.

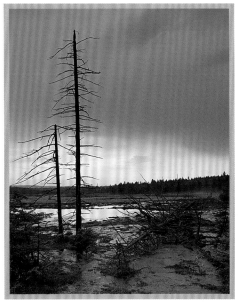

West Virginia's diversity goes beyond the mere geological. Few places in the country present such a diversity of flora as The Mountain State. At lower elevations one encounters trees characteristic of the mountains of the South – rhododendron, laurel, and the like – whereas higher elevations resemble the taiga and tundra of the far North. Where there are trees, spruce and pine dominate the high mountain plateaus of the Allegheny Front; where there are none, blueberry and cranberry eke out an existence within the vast upland bogs.

I cannot help but be inspired by West Virginia's awesome scenery. In shooting images for this book, I have endured freezing cold, howling winds, pelting rains, and (worst of all from a photographer's point of view!) the occasional nice day. Yet I have loved every minute of it. West Virginia is full of wonder and possibility, and truly is an outdoor enthusiast's paradise. I hope you enjoy West Virginia as much as I have.

- Ian J. Plant, May 2005

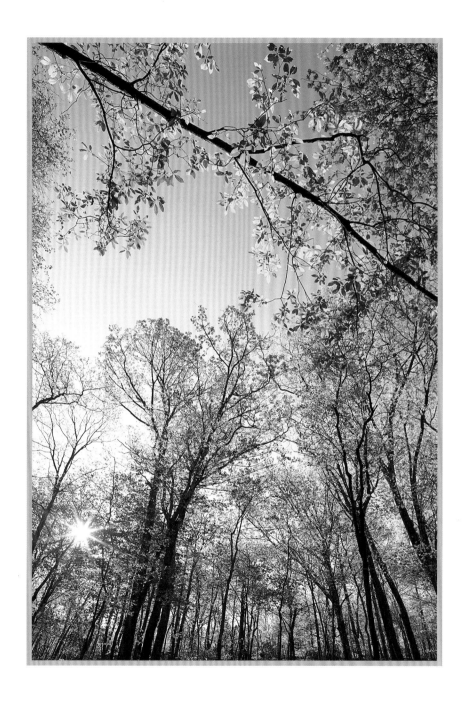

Above: Spring trees, George Washington National Forest

Left: Dusk descends over Fisher Spring Bog

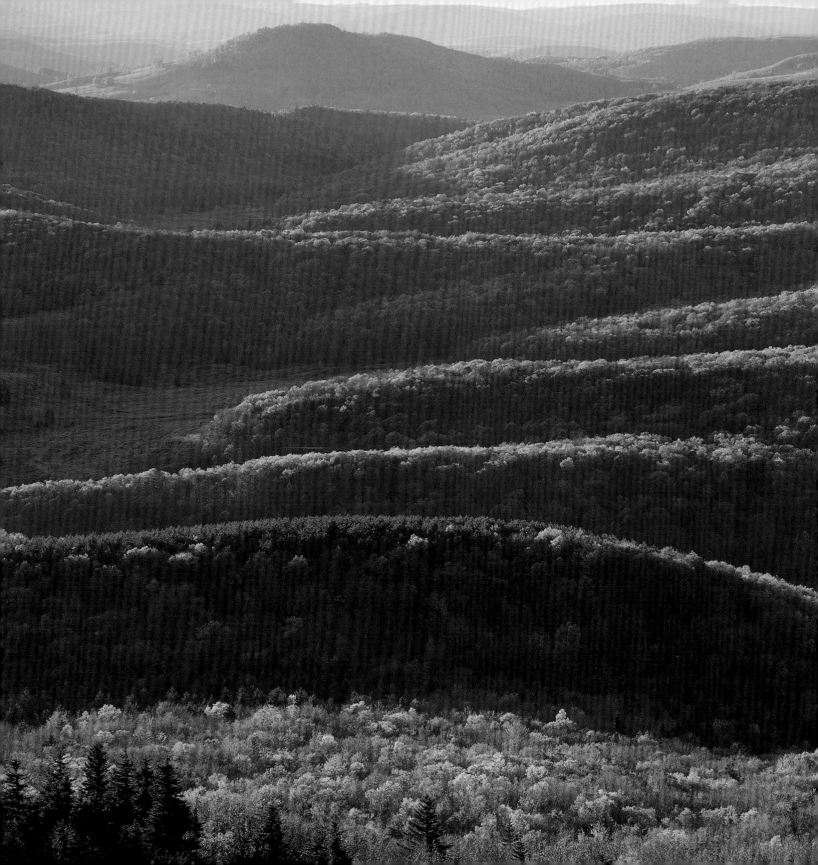

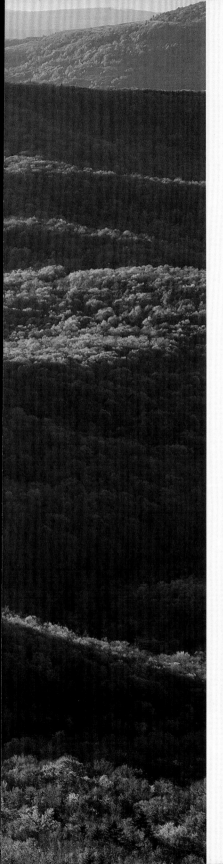

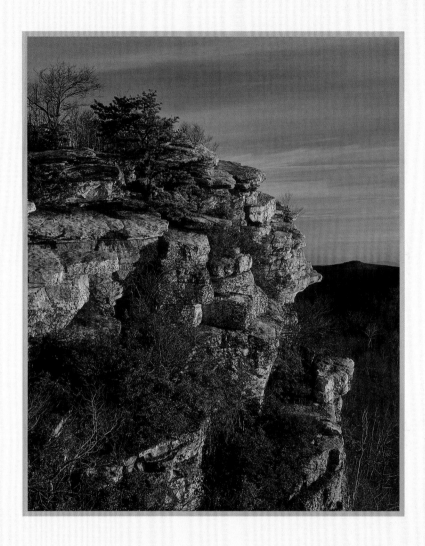

Left: Autumn ridges on the slopes of Spruce Knob Mountain

Above: Sunrise light on Big Schloss Mountain, in the George Washington National Forest on the border of Virginia and West Virginia

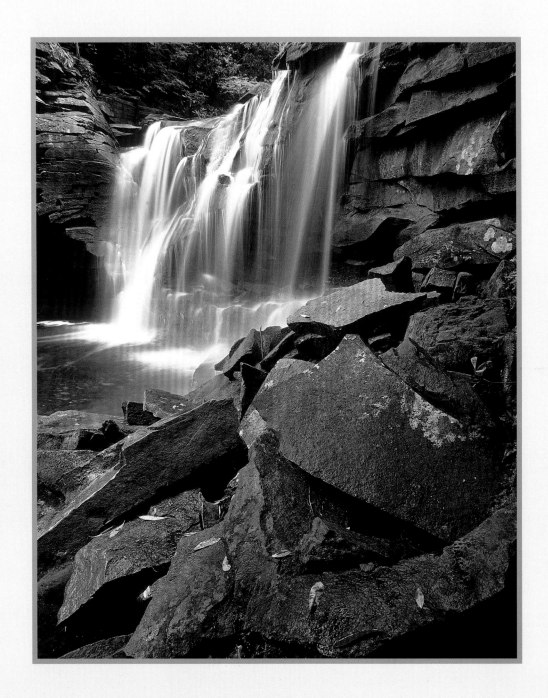

Elakala Falls, Blackwater Falls State Park

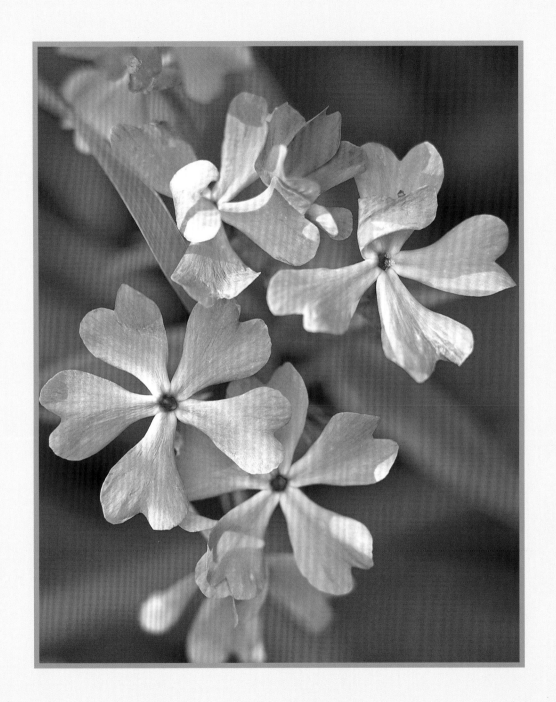

Wild blue phlox

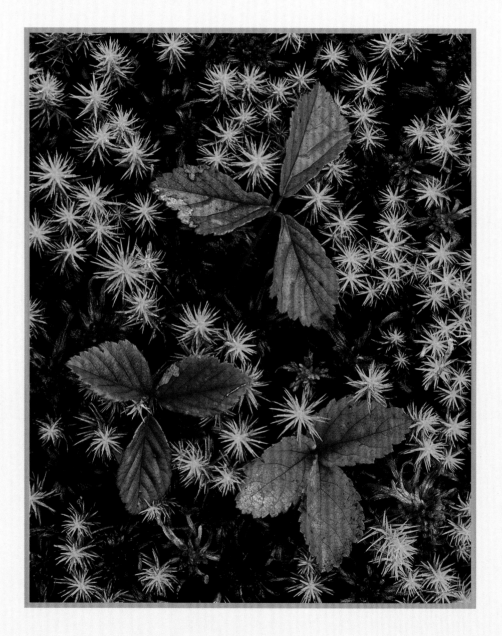

Above: Autumn leaves and moss

Right: Douglas Falls

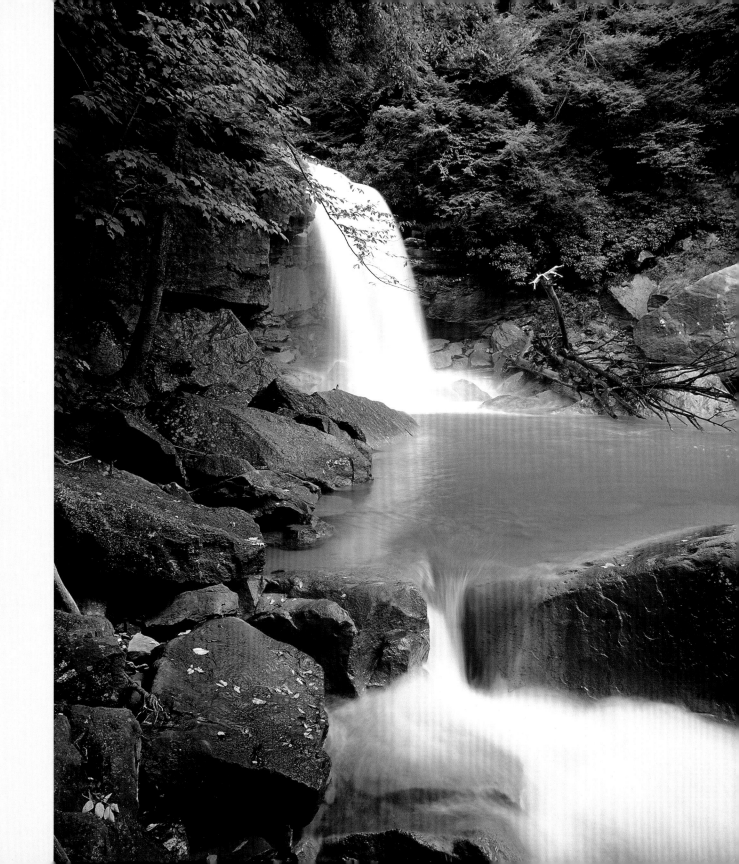

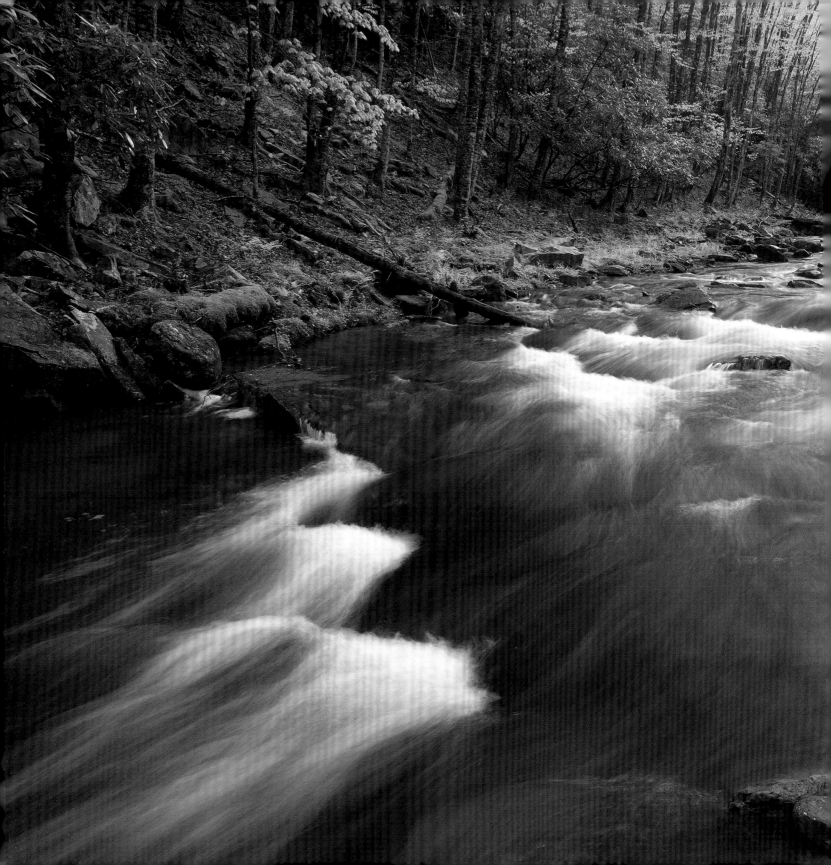

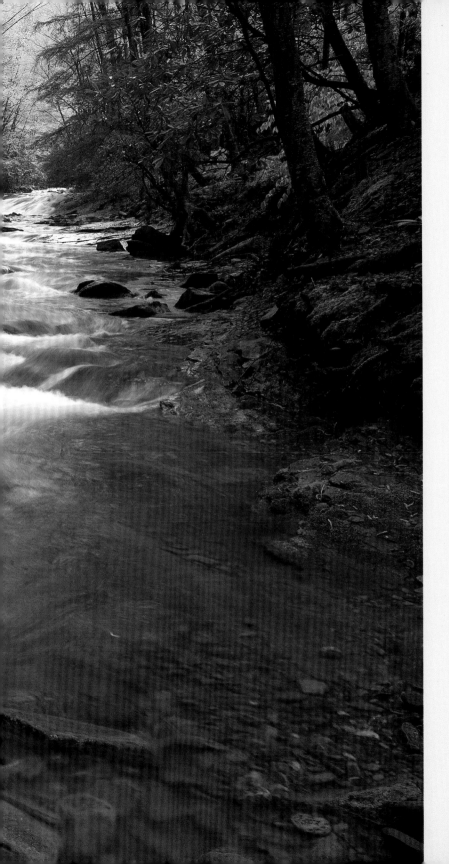

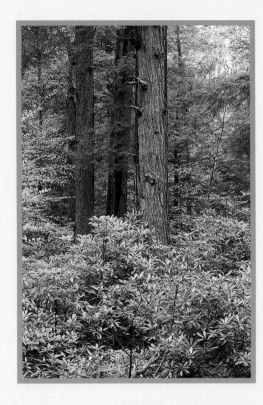

Left: Spring rains swell Seneca Creek in the
Monongahela National Forest

Above: Ancient hemlock trees tower over rhododendron
in Cathedral State Park

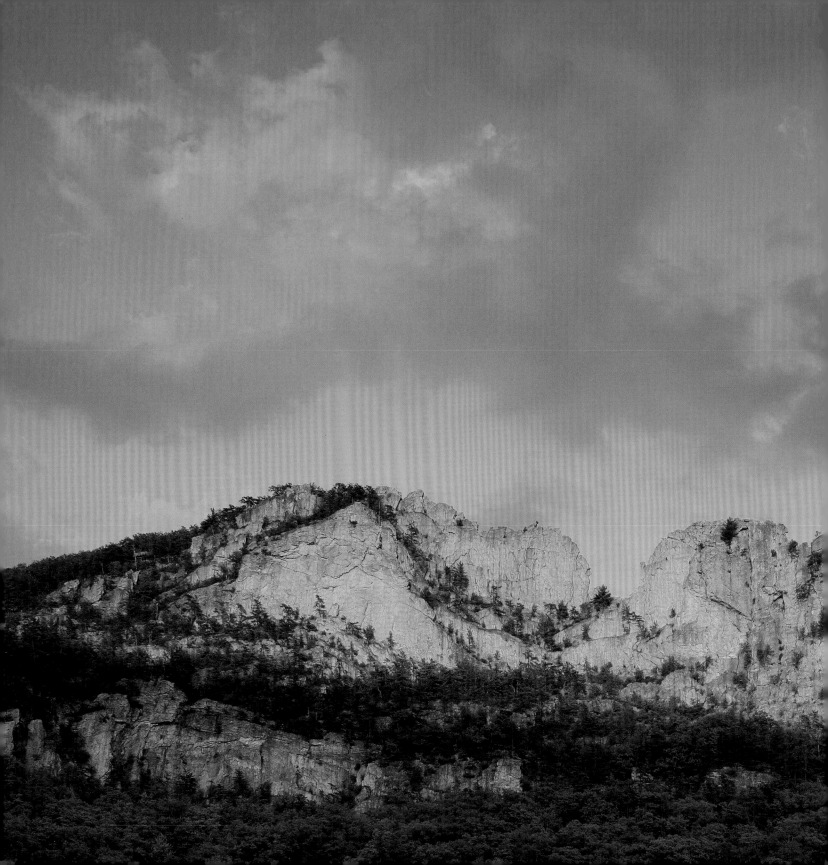

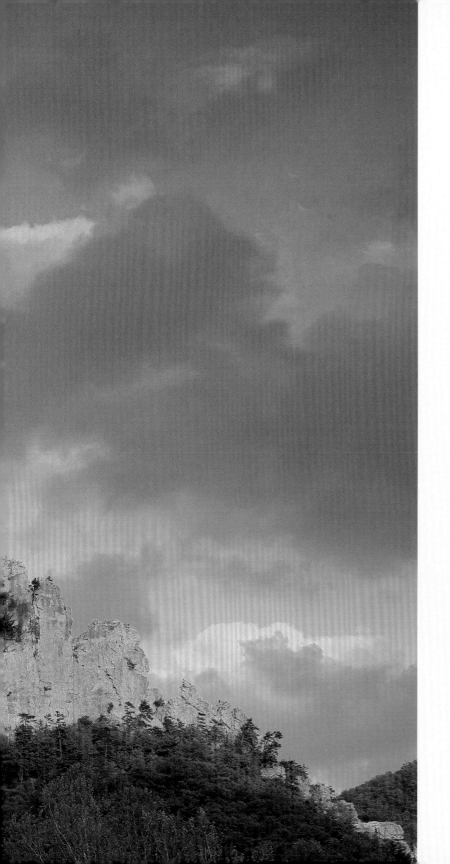

Left: Sunset sets the soaring sandstone cliffs of Seneca Rocks afire with golden light. Seneca Rocks are made of white and gray Tuscarora quartzite, which is composed of fine grains of sand that were laid down approximately 440 million years ago. Continental uplift followed by millions of years of erosion have stripped away the overlaying rock and left Seneca Rocks to tower a thousand feet over the valley below.

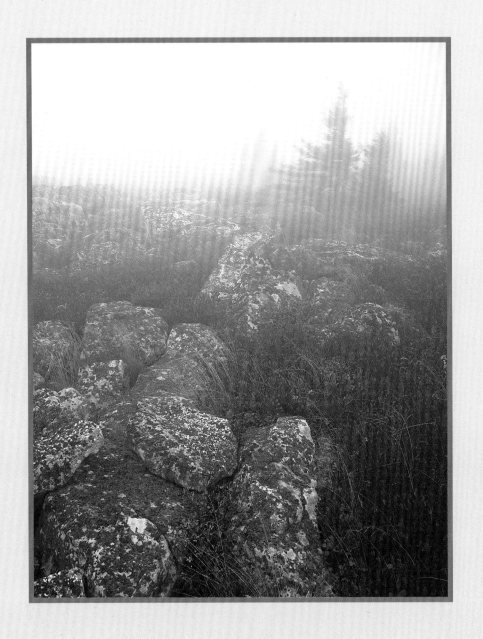

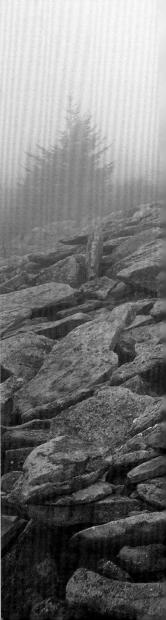

Above: High mountain heath turns crimson in autumn in the West Virginia highlands

Left: Fog shrouds the summit of Spruce Knob, West Virginia's highest mountain

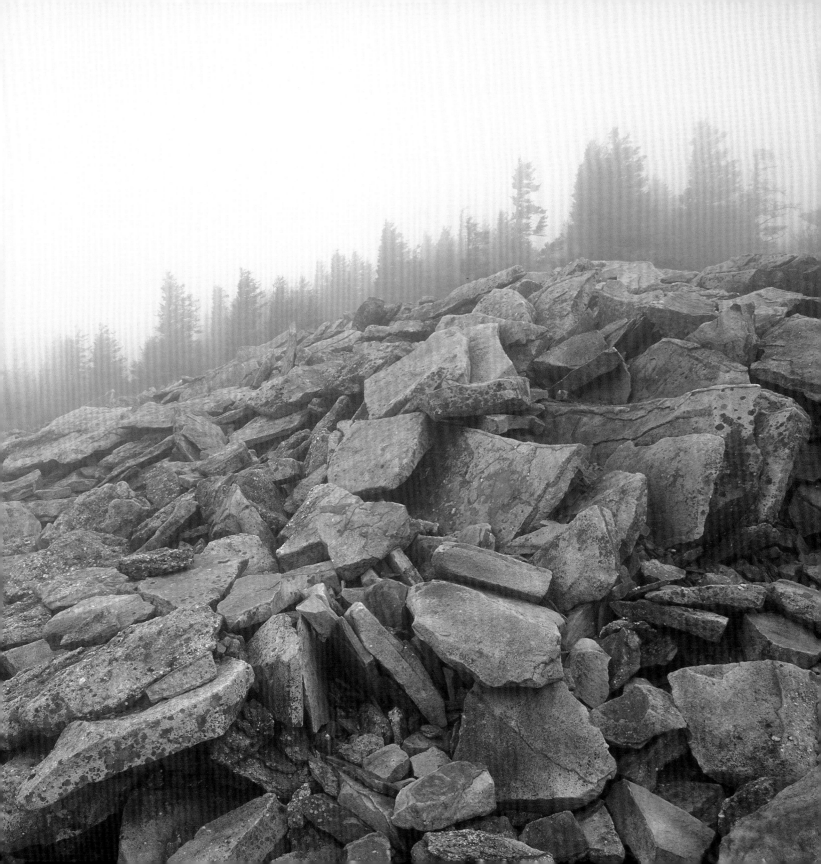

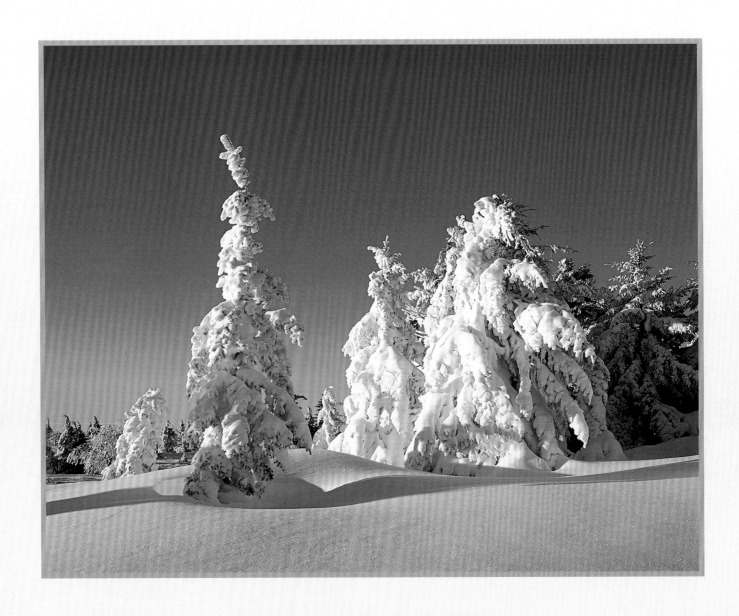

Above: Snow covers spruce trees on Cabin Mountain

Right: Sunrise on Summersville Lake

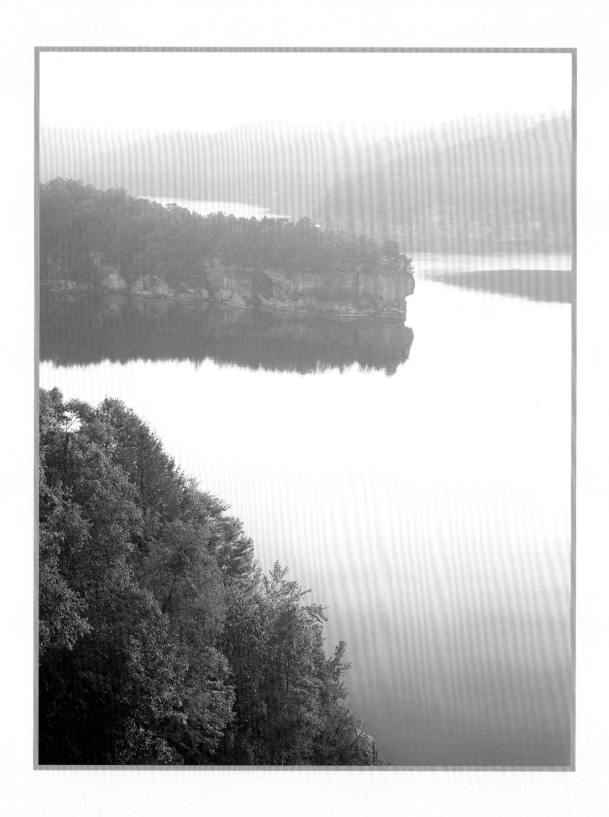

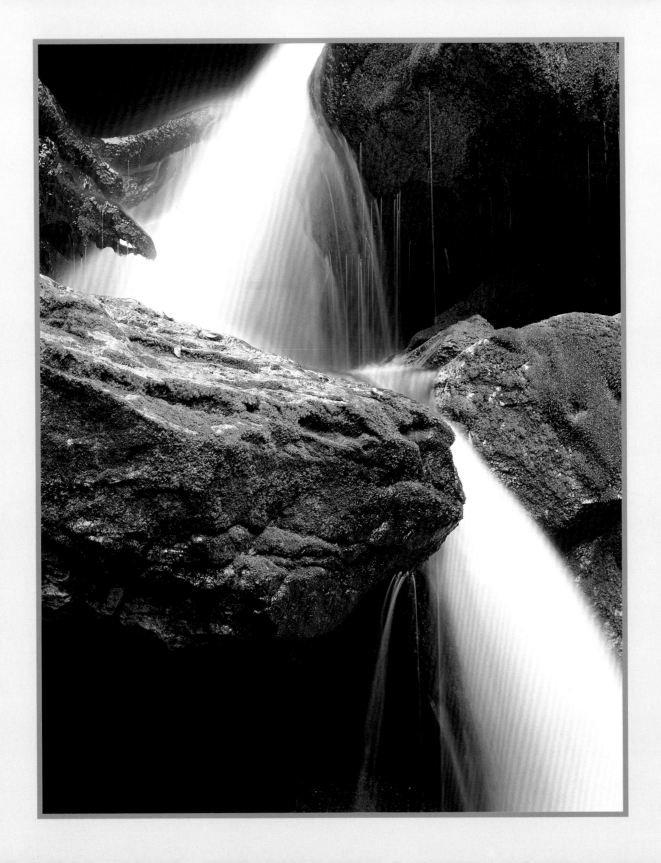

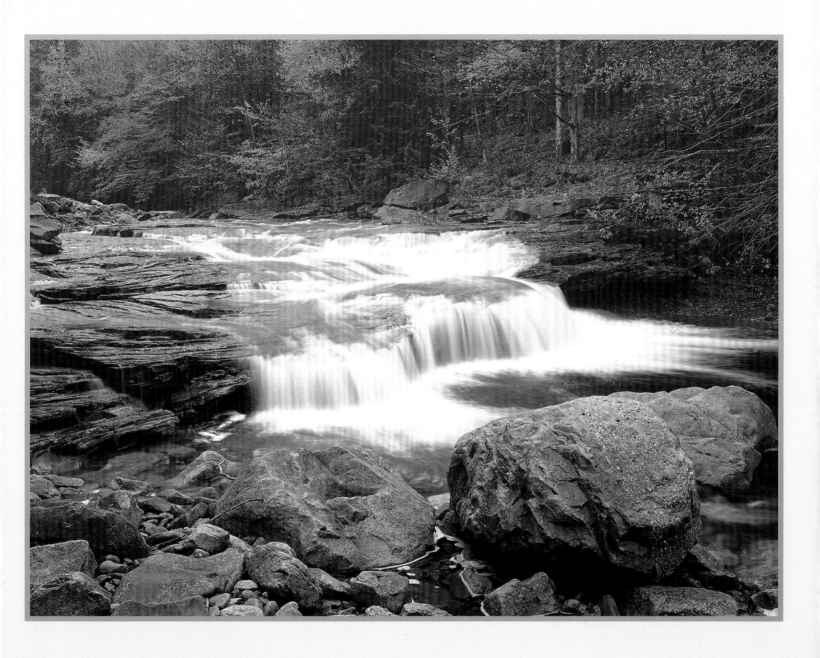

Left: Cascade on Shay's Run

Above: Red Creek Falls

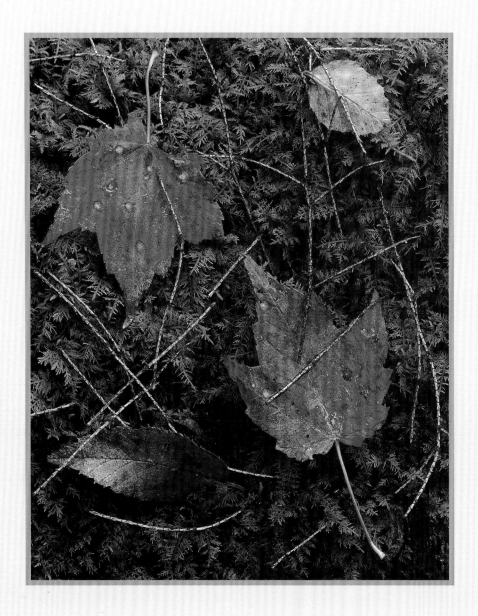

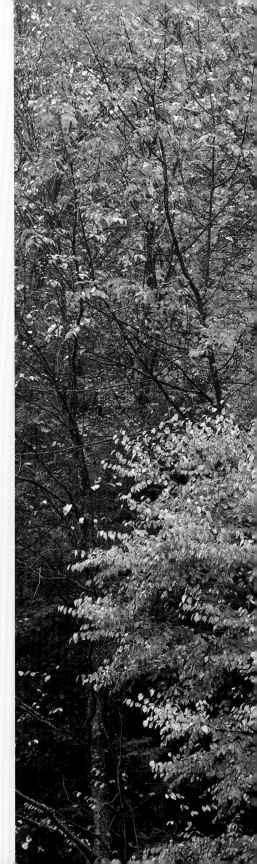

Above: Fall still-life

Right: Autumn watercolor paints the Dolly Sods Wilderness

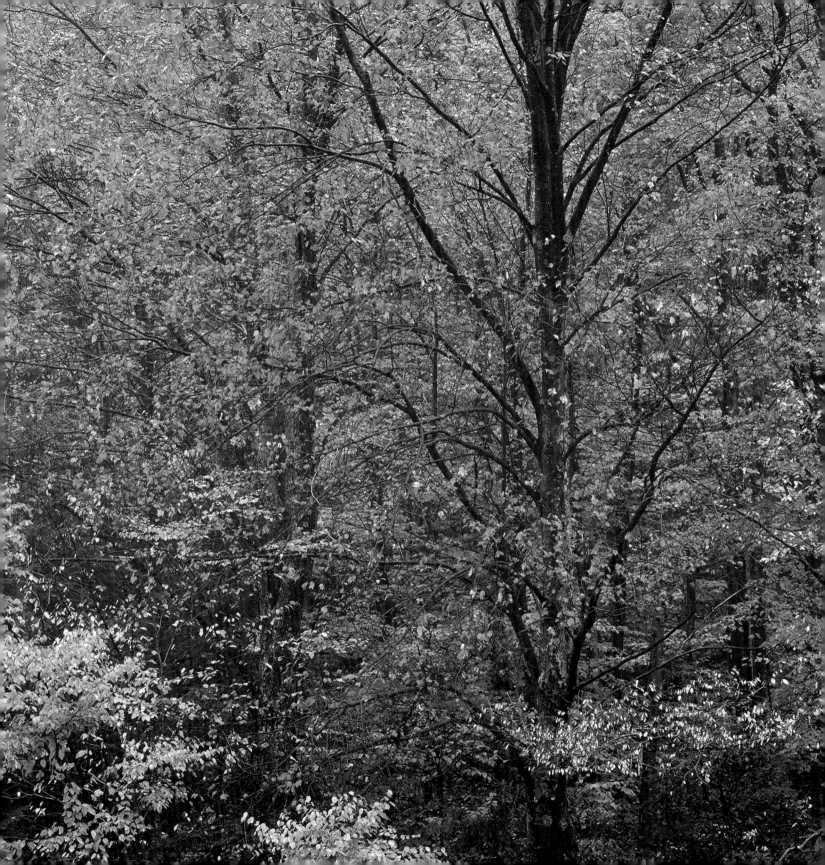

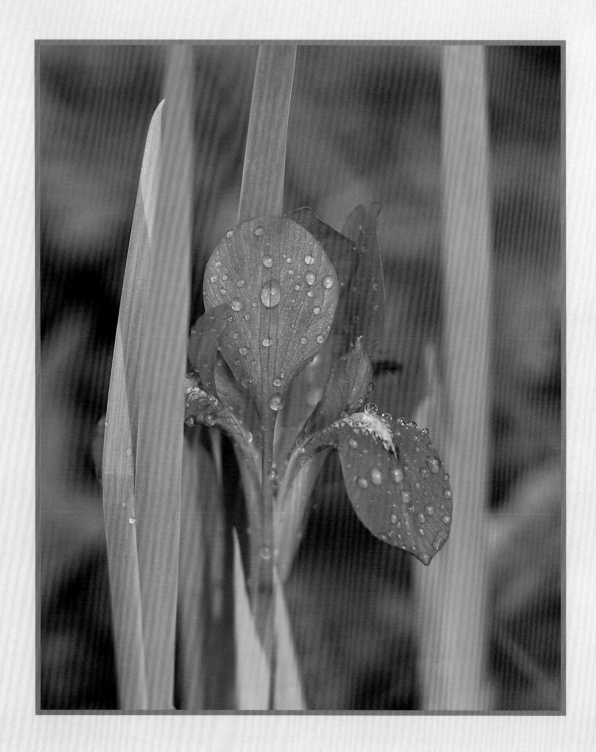

Crested dwarf iris

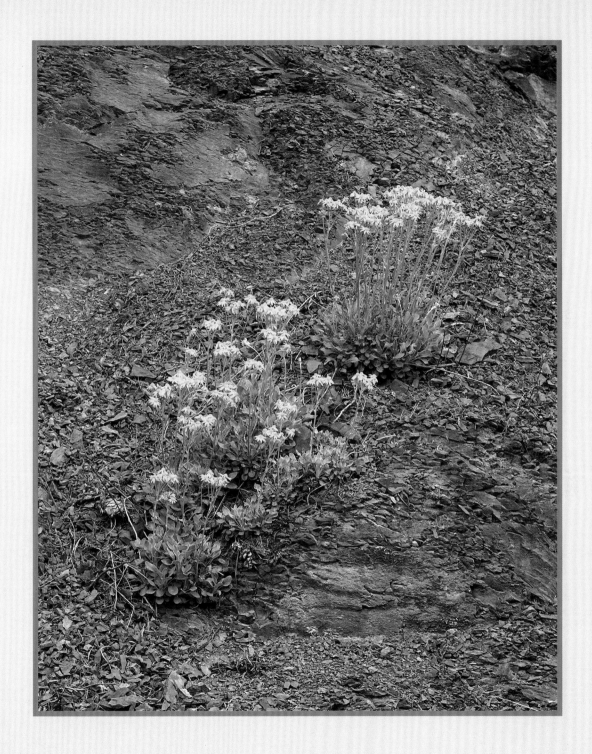

Woodland sunflowers cling to life on an eroded rocky slope

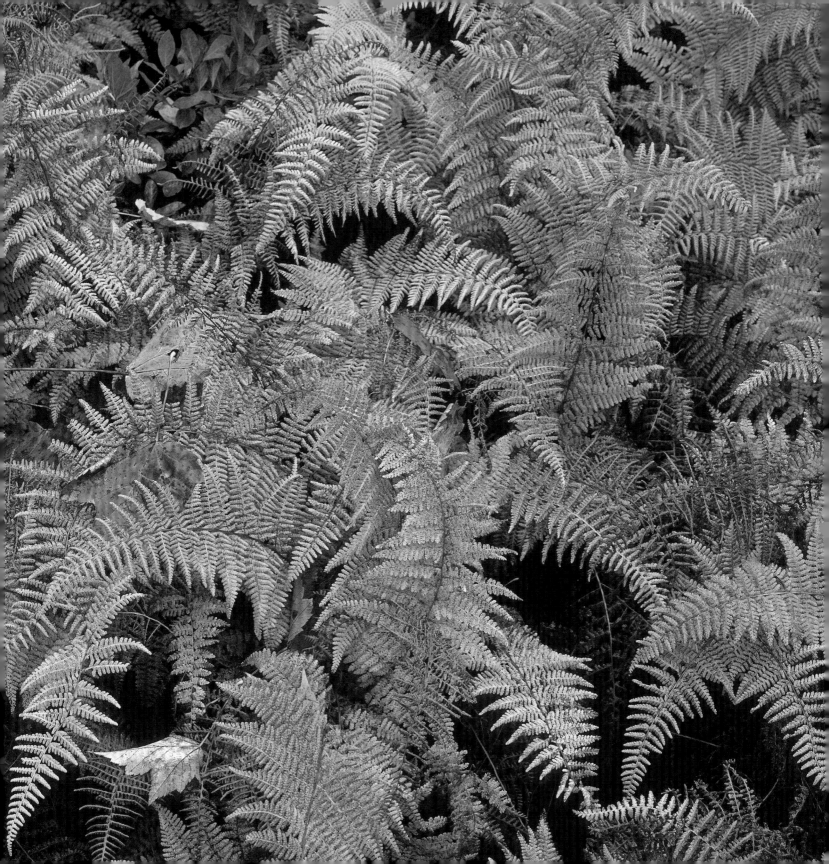

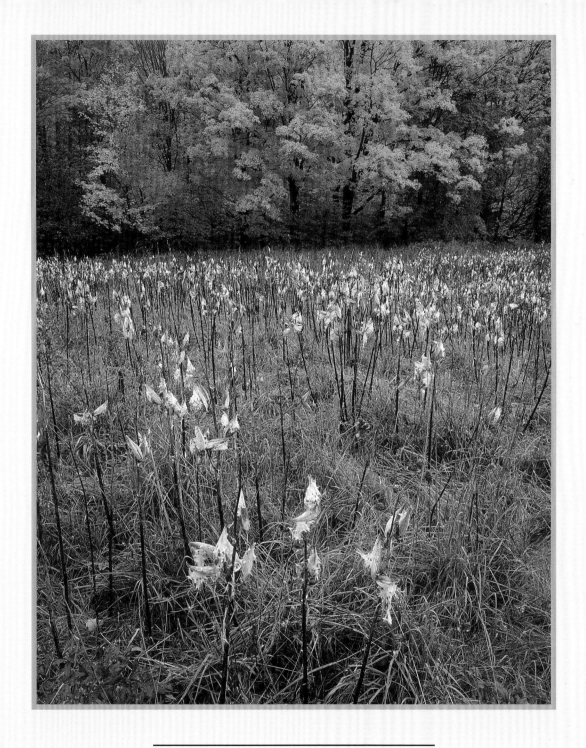

Left: Hay-scented fern

Above: Milkweed and maple

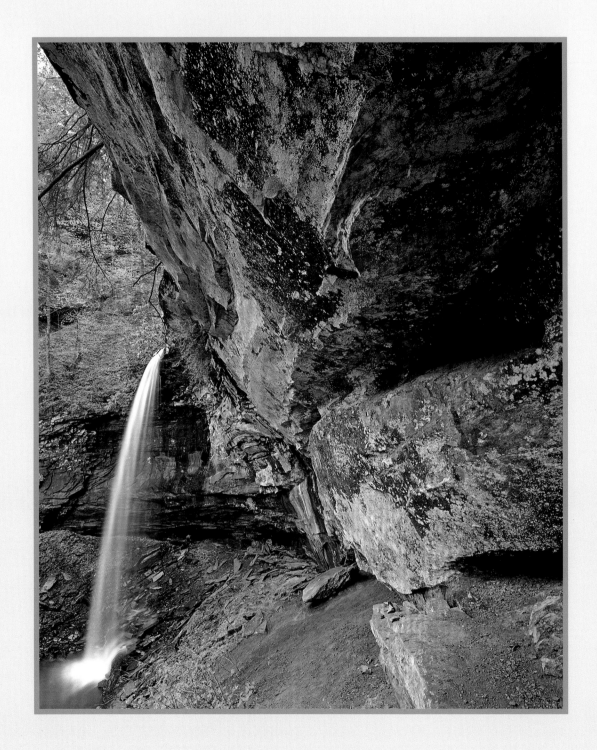

Lower Falls of Hills Creek

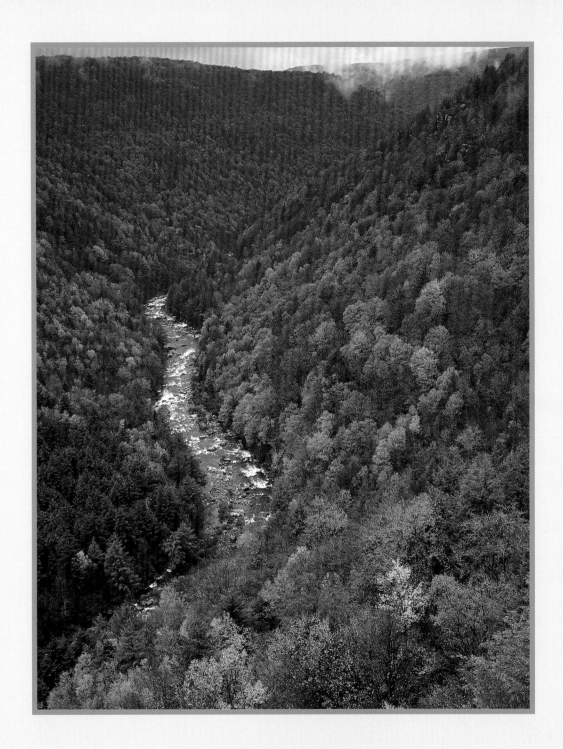

Blackwater Canyon

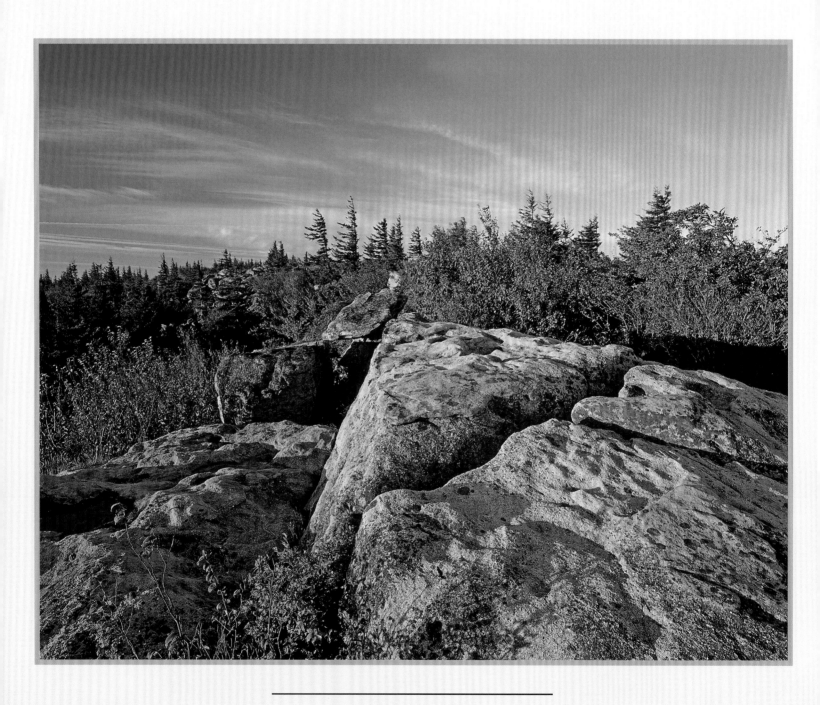

Above: Sunrise lights boulders in the Dolly Sods Wilderness

Right: Water tumbles over a cliff on Pendleton Run

Next page: Morning mist breaks over a peak in the Monongahela National Forest

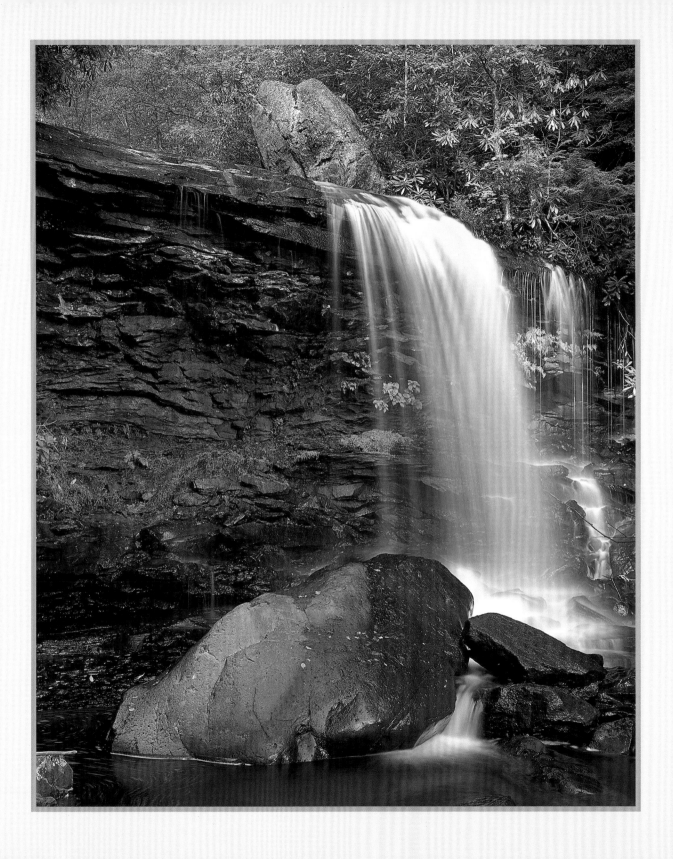

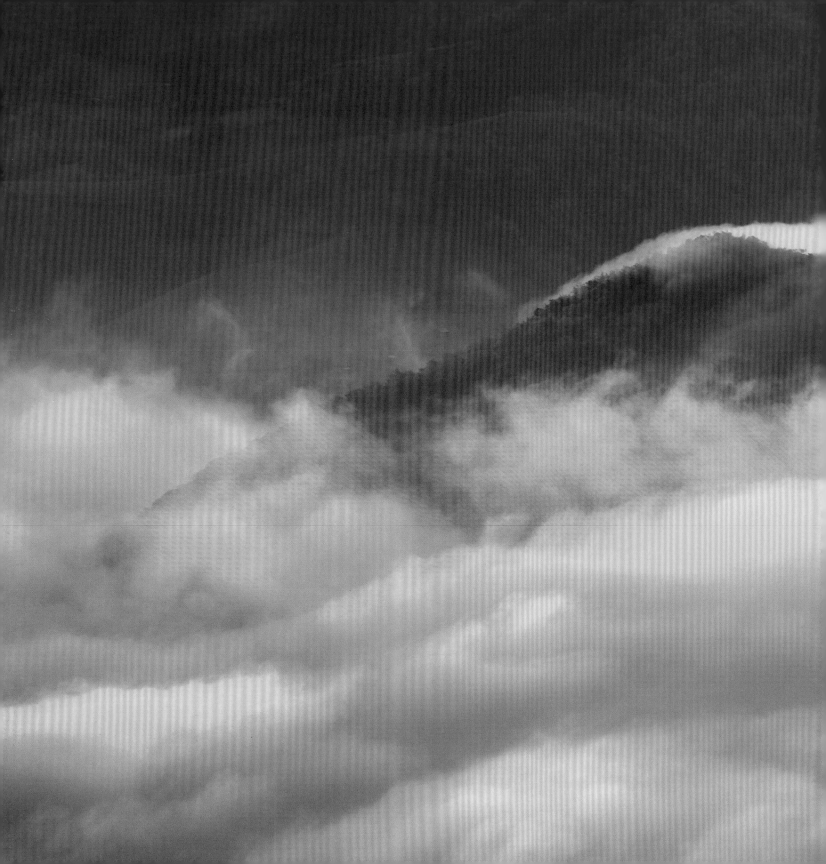

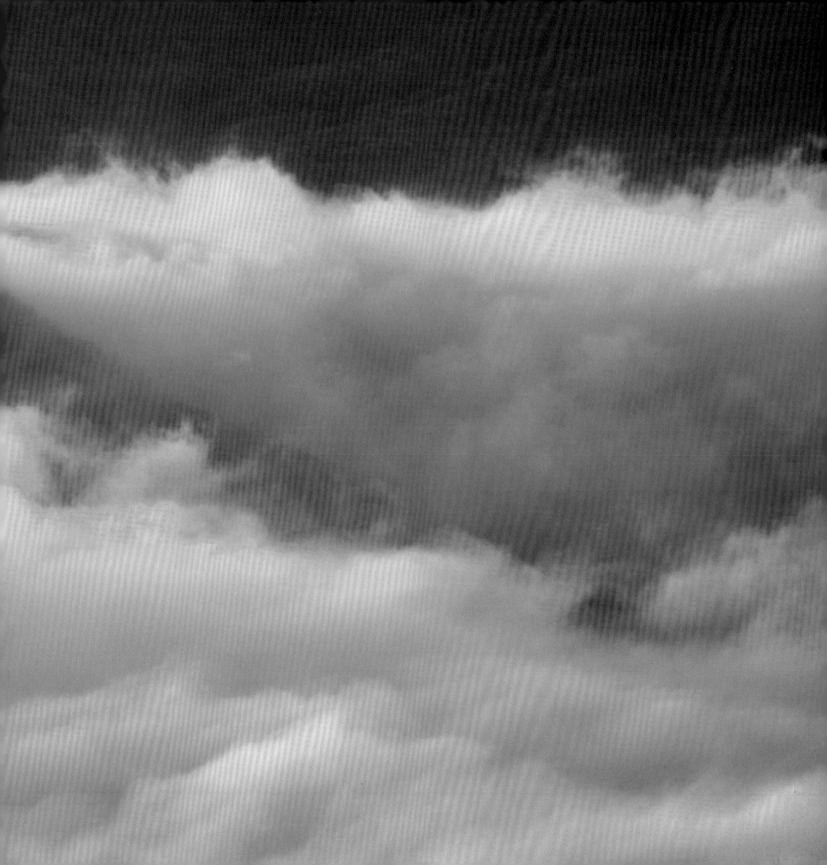

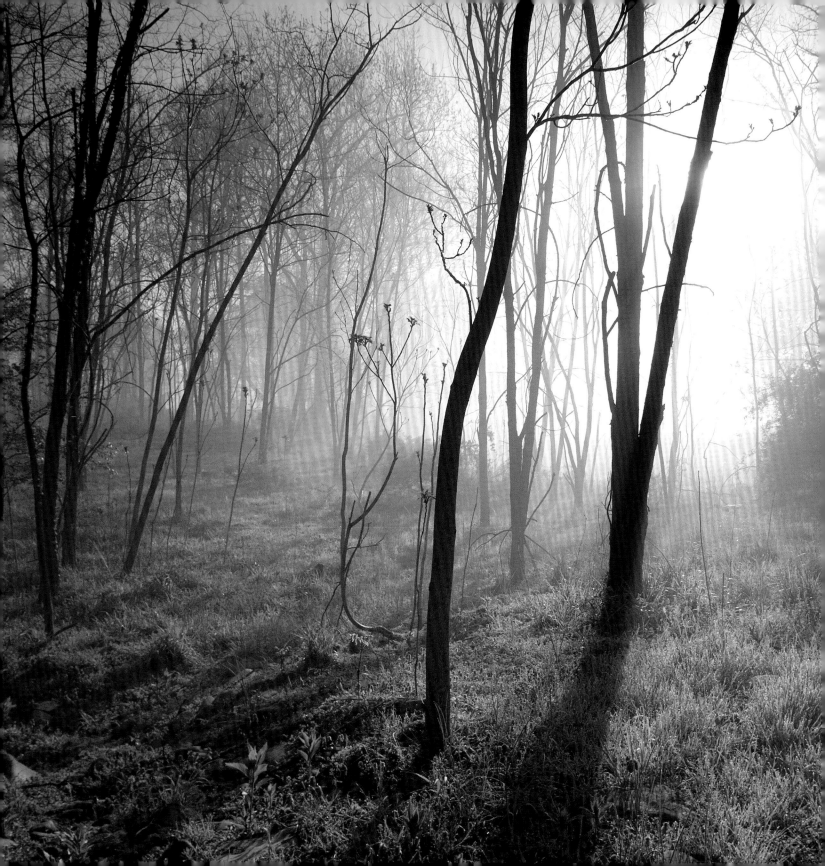

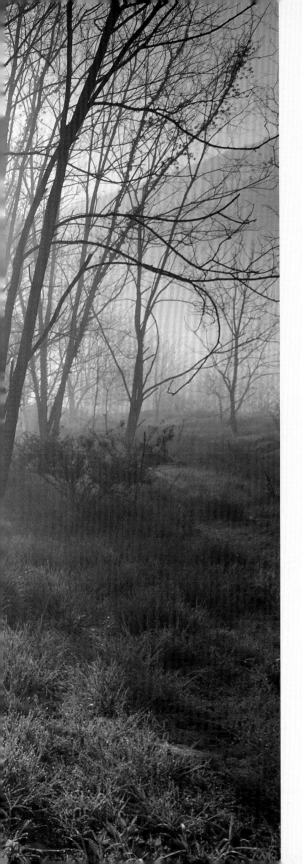

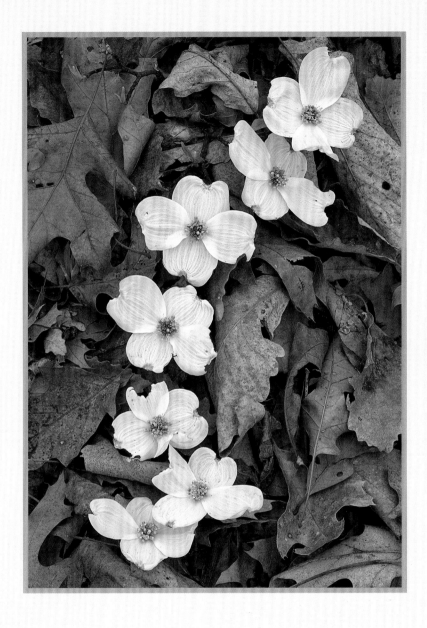

Left: Sunrise through fog, Potomac River Valley

Above: A fallen dogwood branch lies on the forest floor

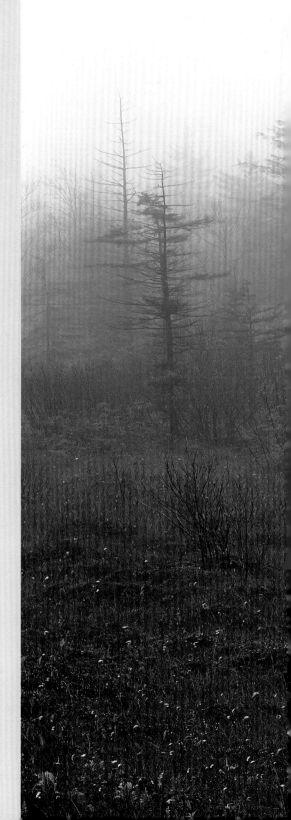

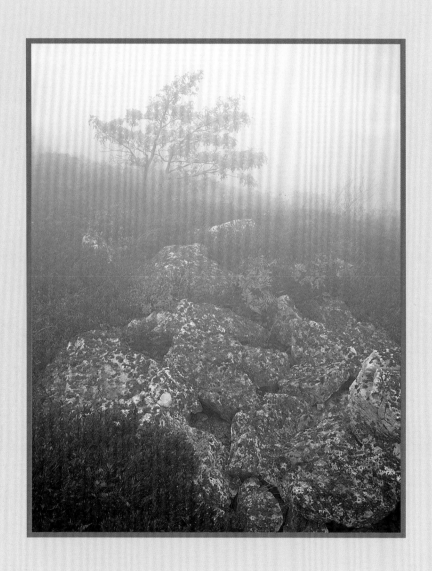

Above: Autumn mist on the Allegheny Plateau

Right: Heath barrens in Canaan Valley

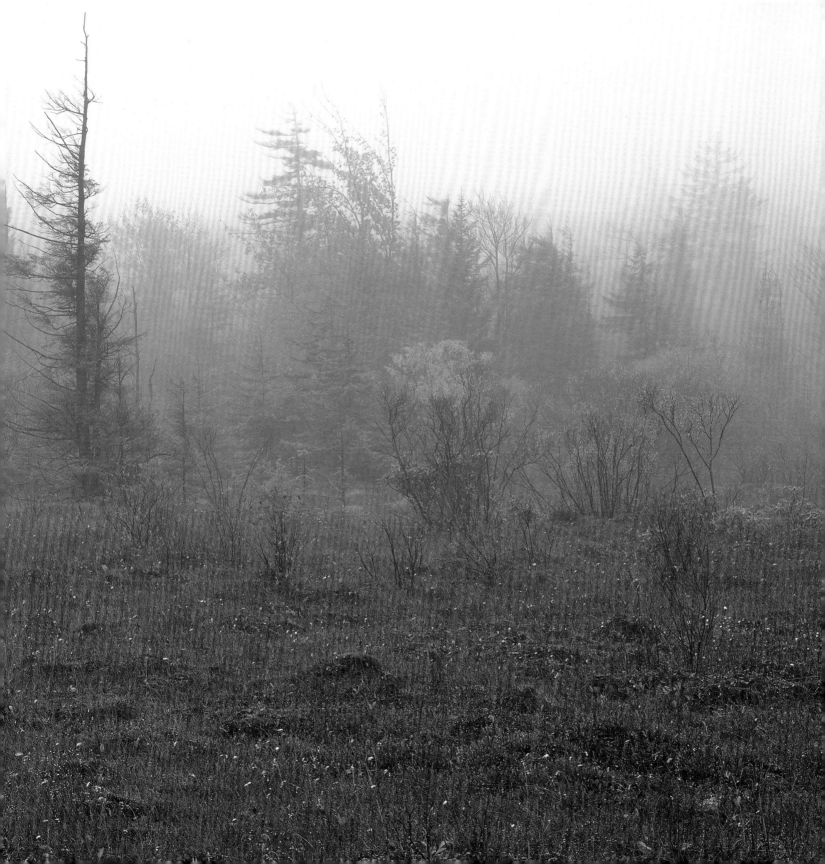

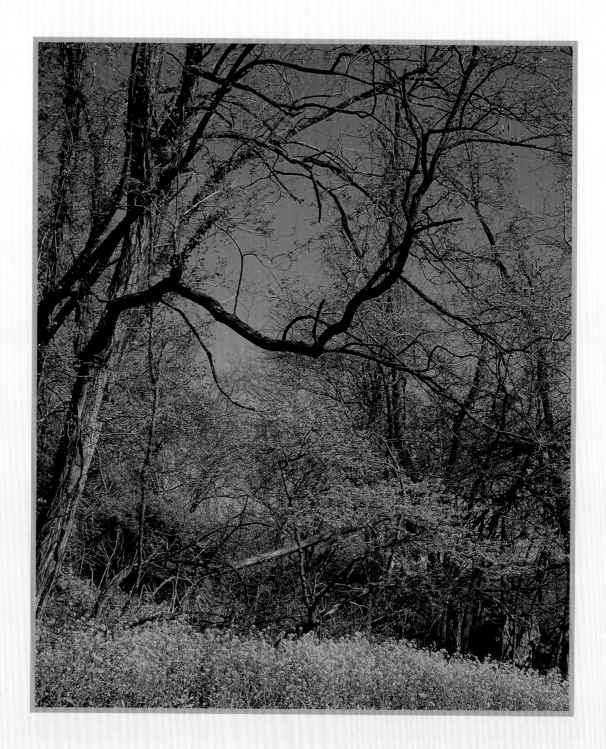

Blooming redbud

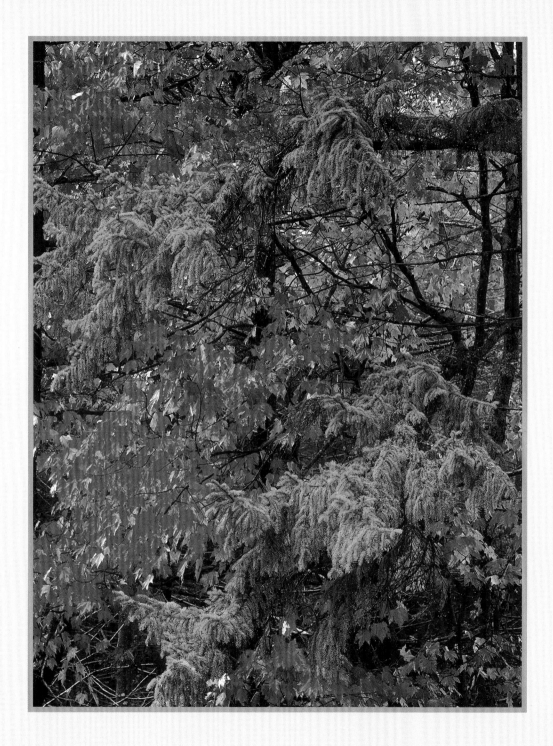

Maple and pine

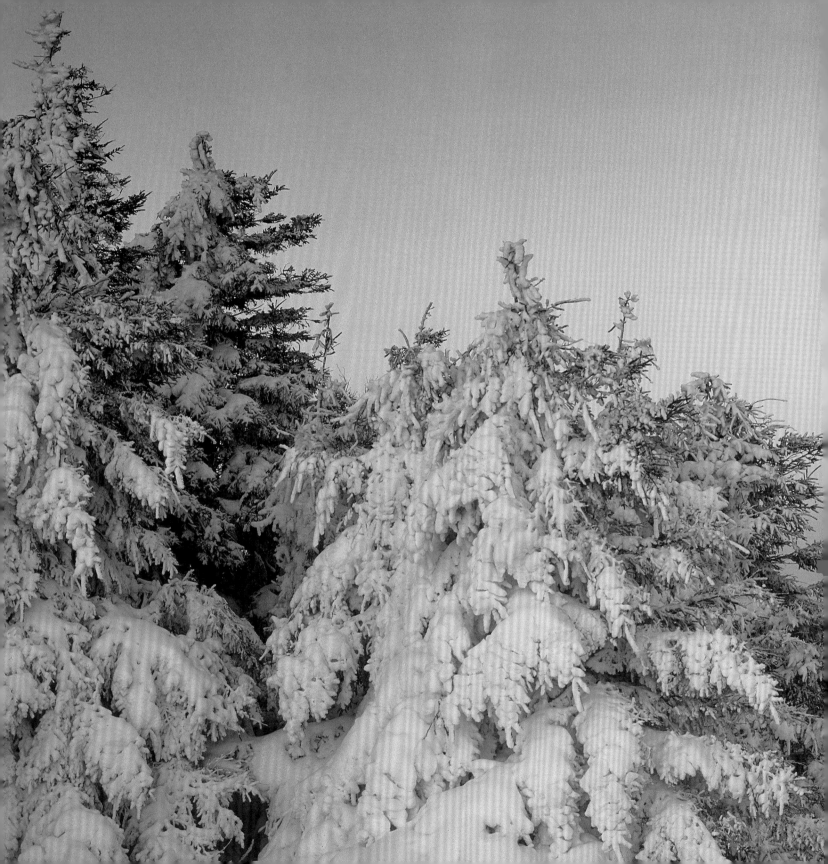

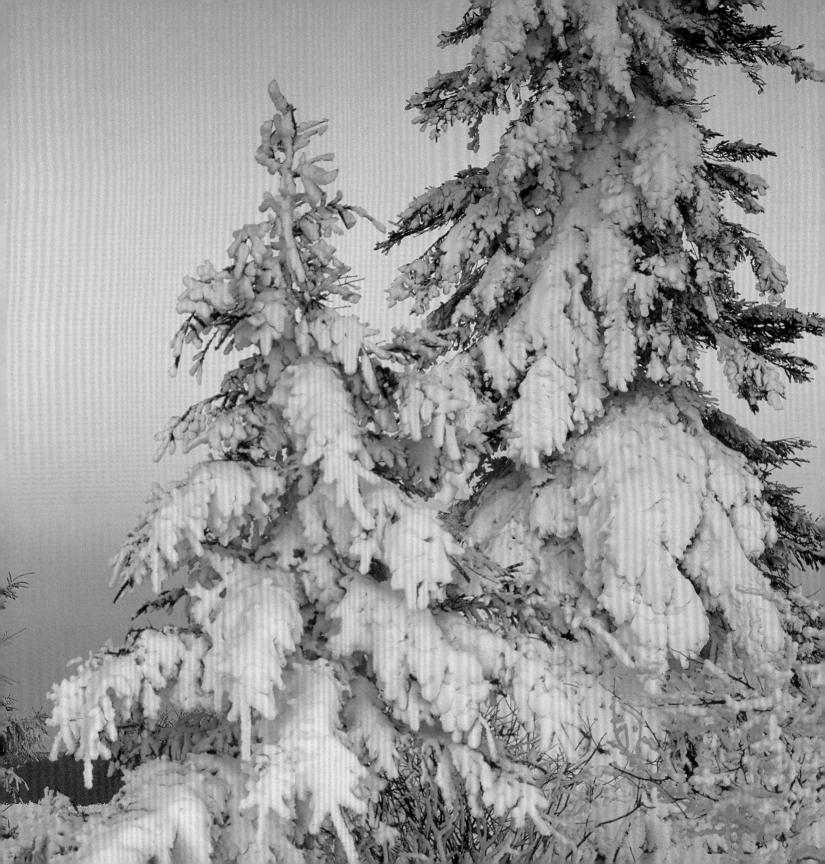

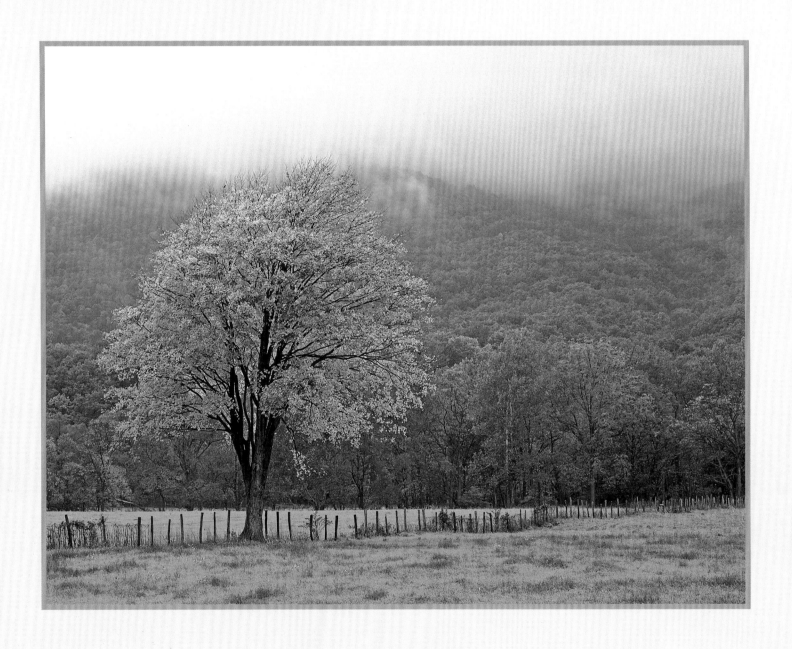

Previous page: Dawn glow framed by frozen trees in the Potomac Highlands

Above: Autumn graces a farmer's field

Right: A rusted railroad trestle spans the New River

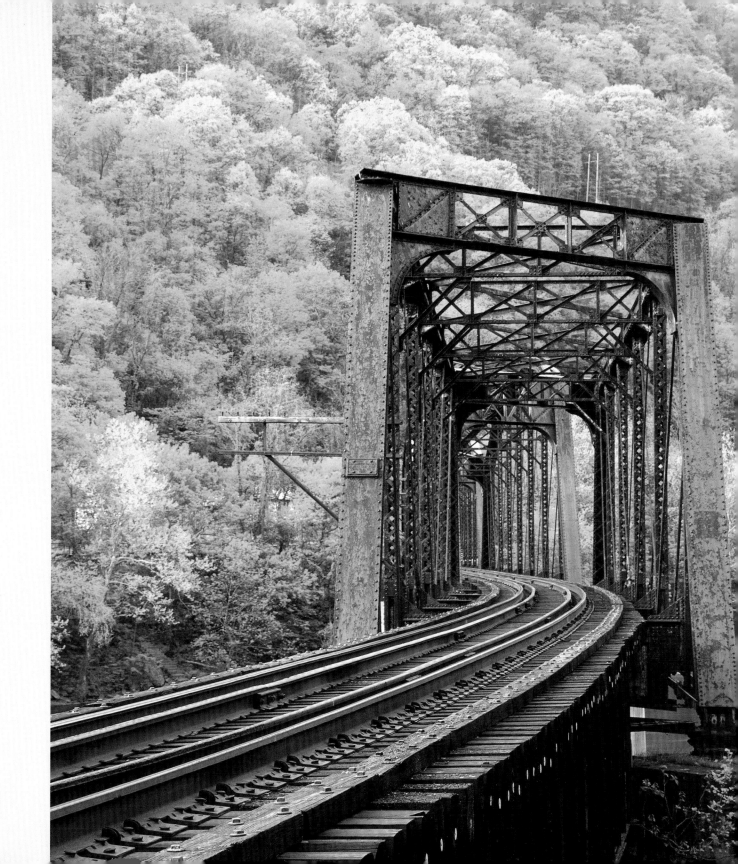

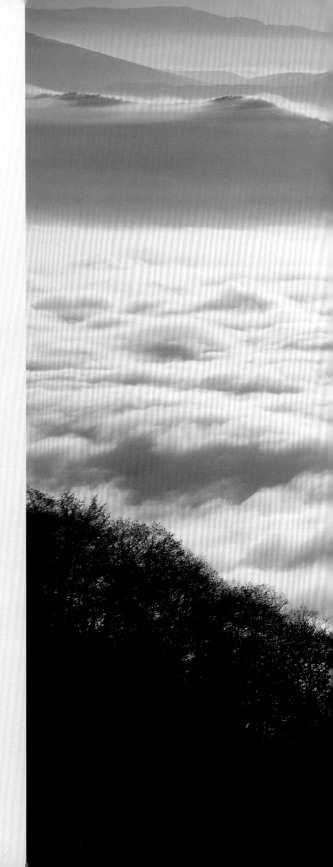

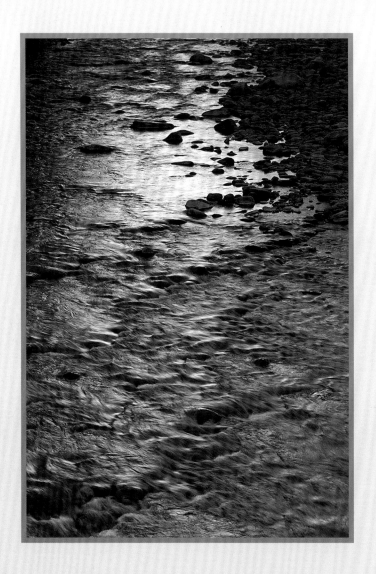

Above: Seneca Creek reflections

Right: A view above the clouds in the Potomac Highlands

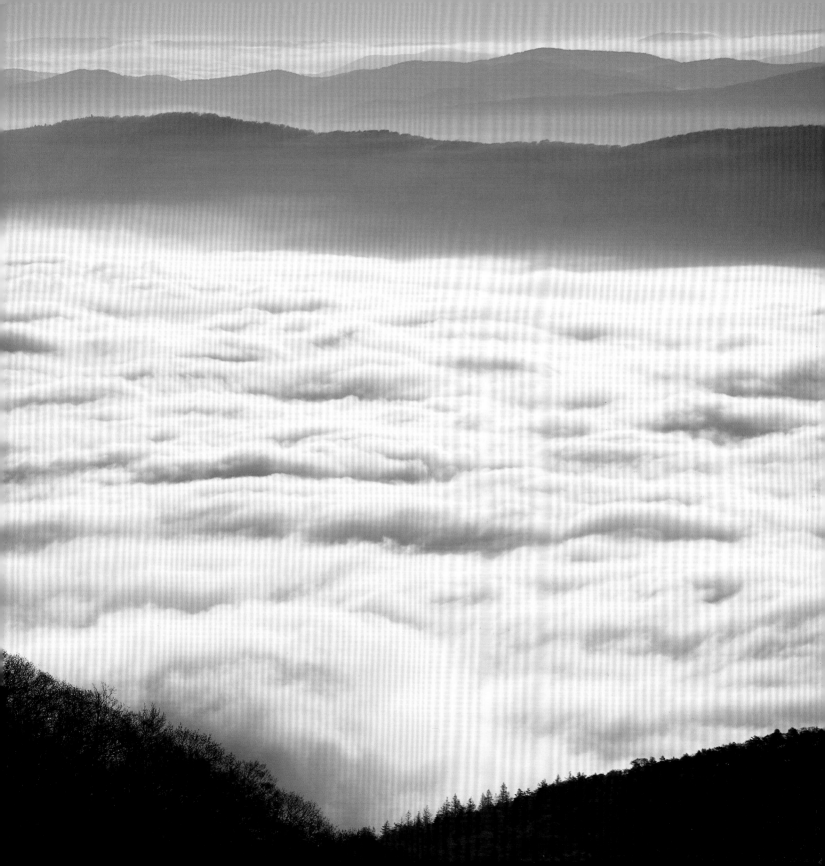

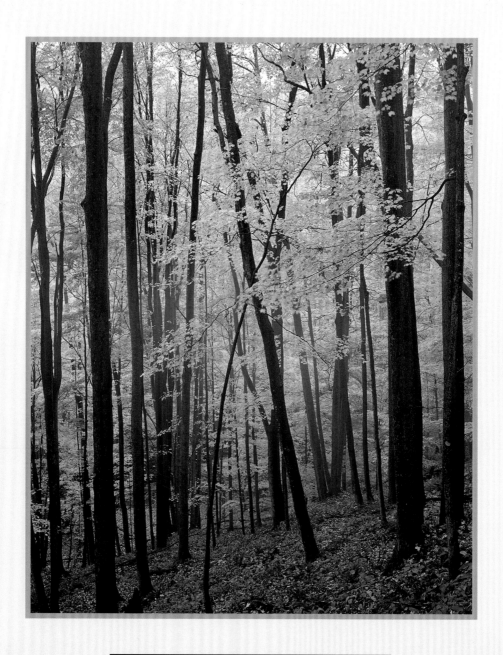

Above: Autumn comes to Canaan Valley

Right: Spring brings lilies to the forest

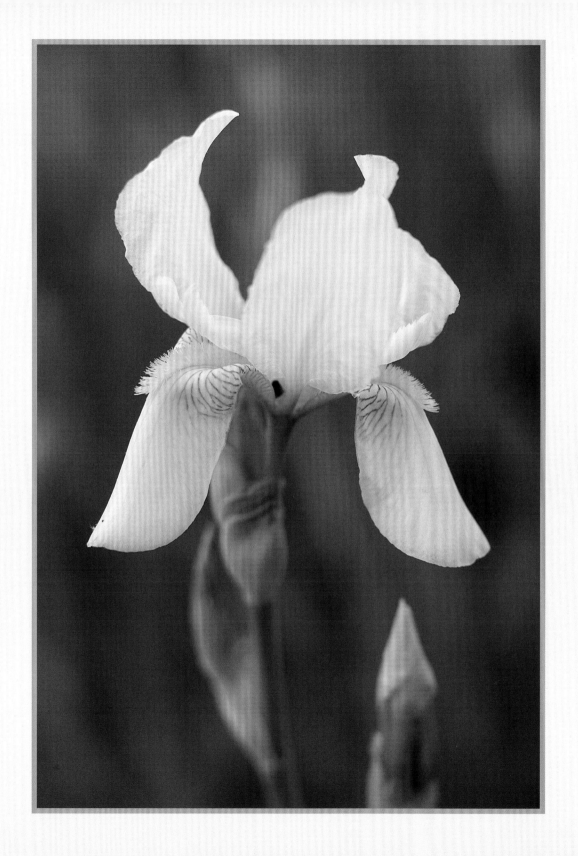

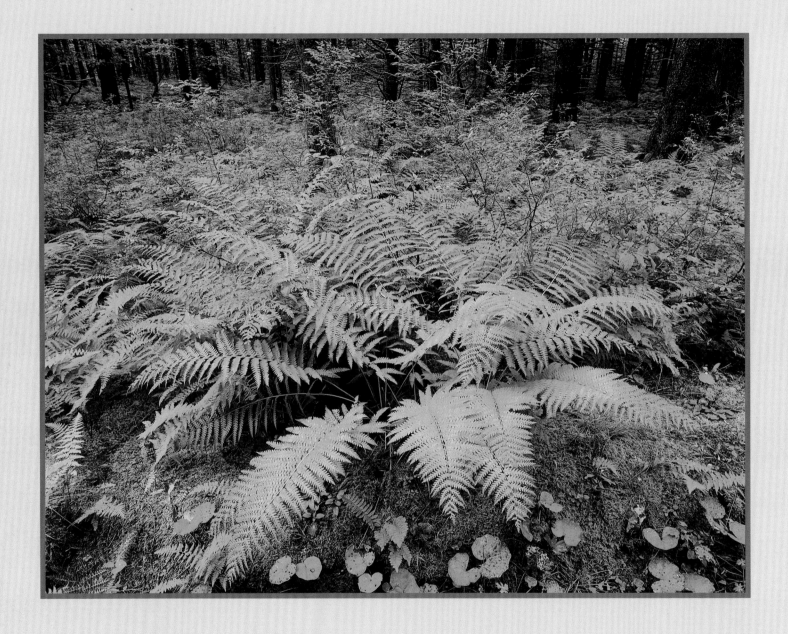

Above: Summer brings ferns in profusion

Right: Ice-covered trees

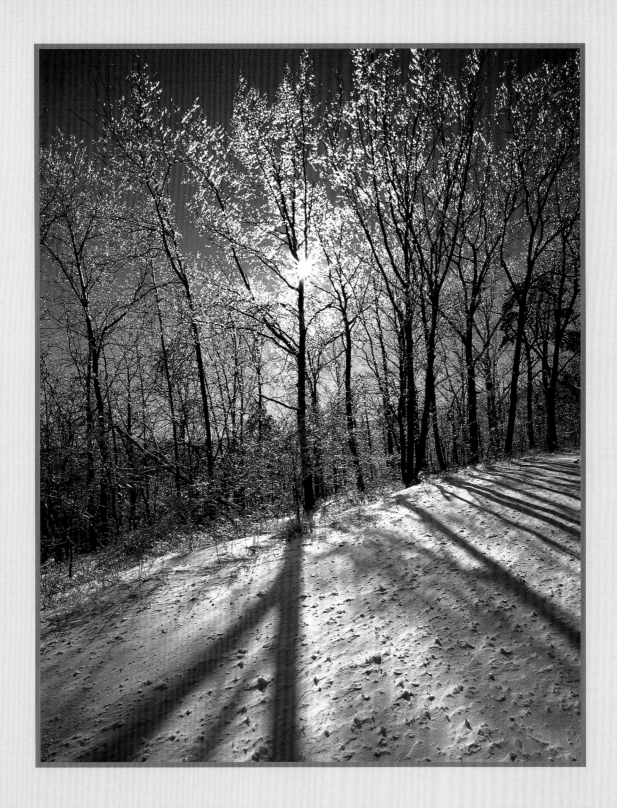

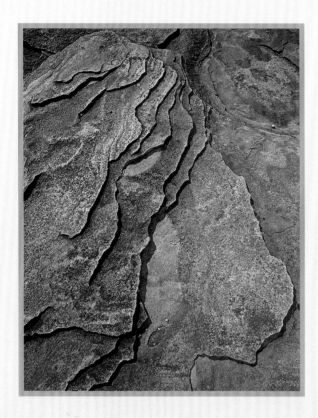

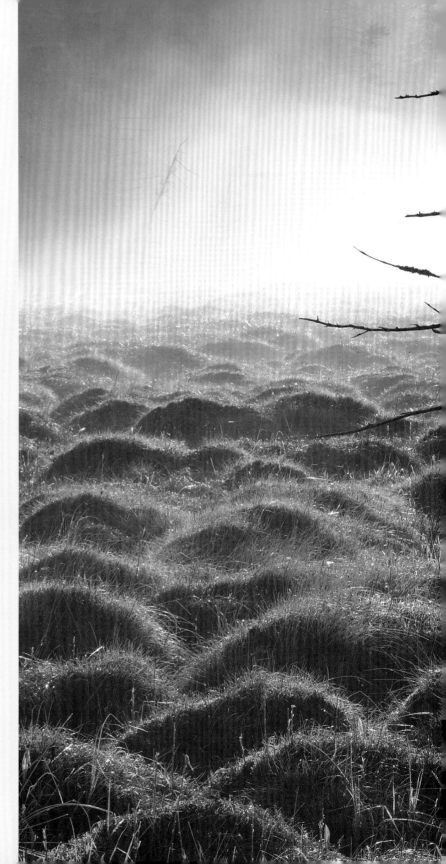

Above: Rock outcropping over the Blackwater Canyon

Right: Upland bogs are common in the Cranberry Glades and Dolly Sods wilderness areas

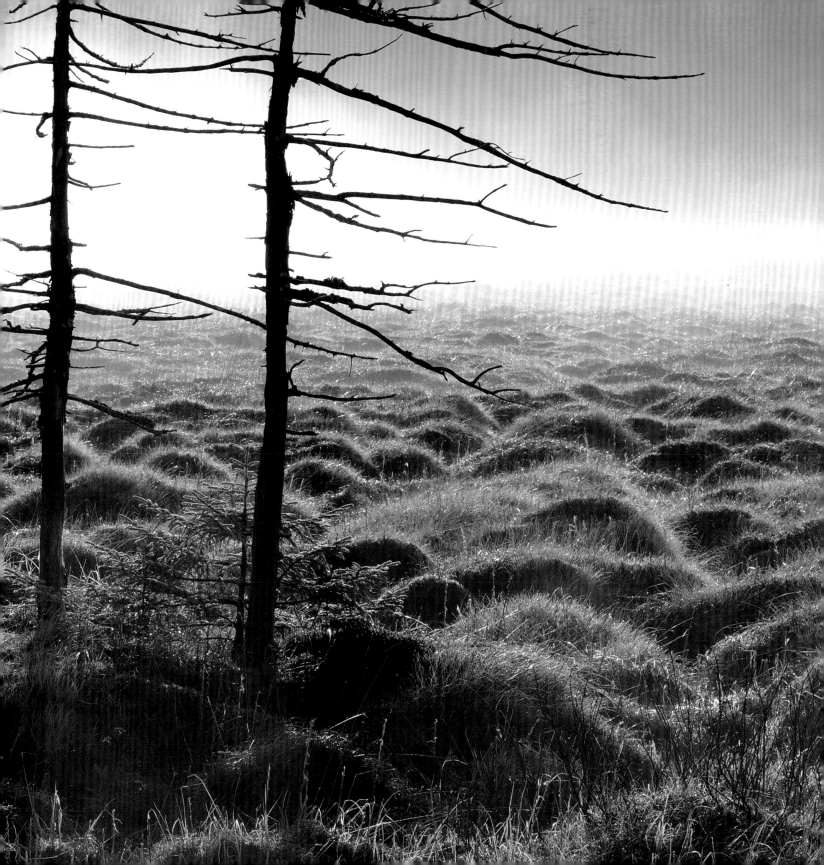

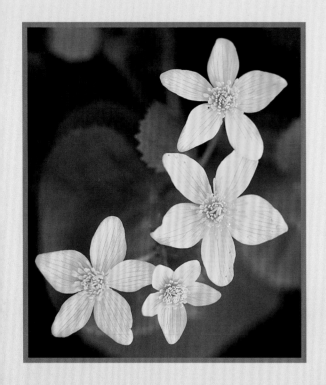
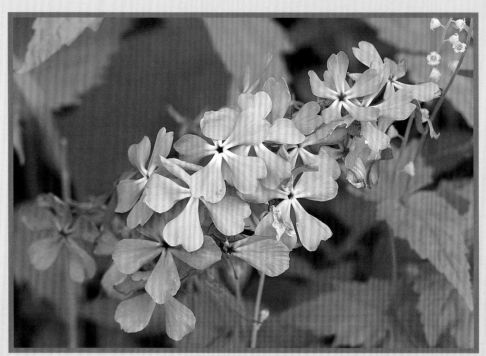
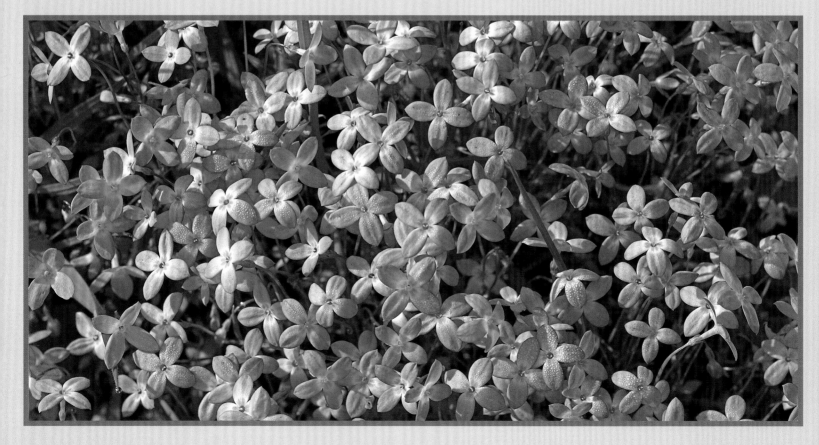

Preceding page, upper left: Marsh marigold

Preceding page, upper right: A cluster of wild blue phlox

Preceding page, lower: Bluets bloom in profusion

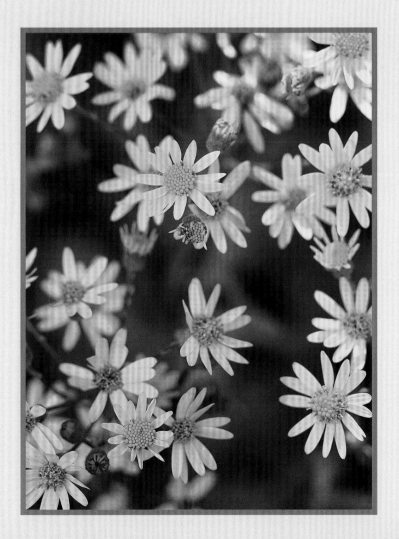

Above: Trillium

Left: Woodland sunflower

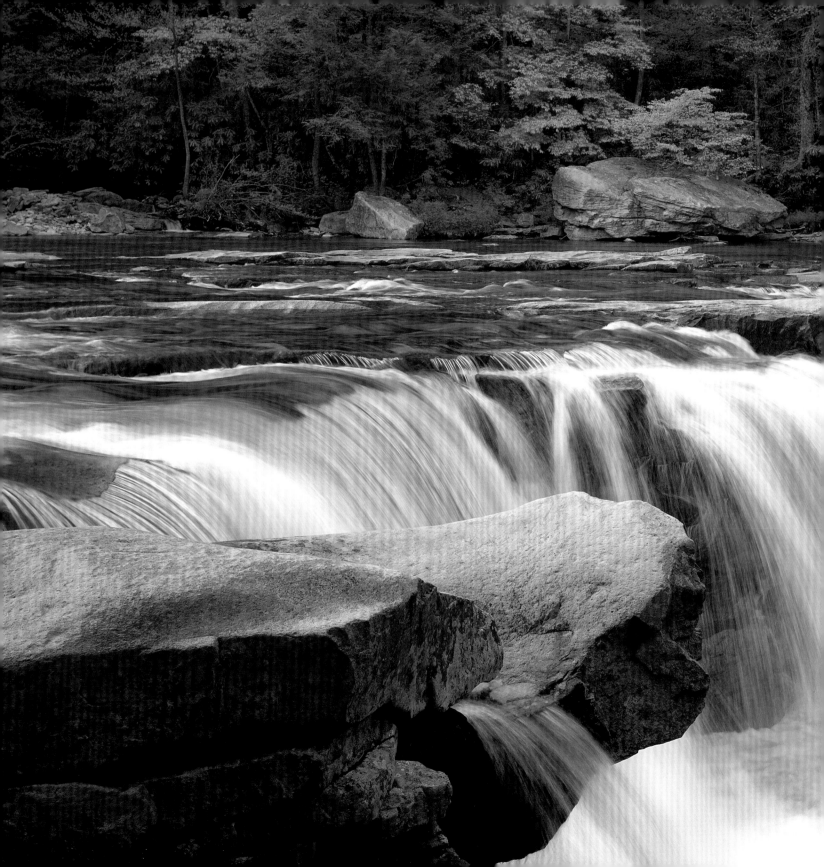

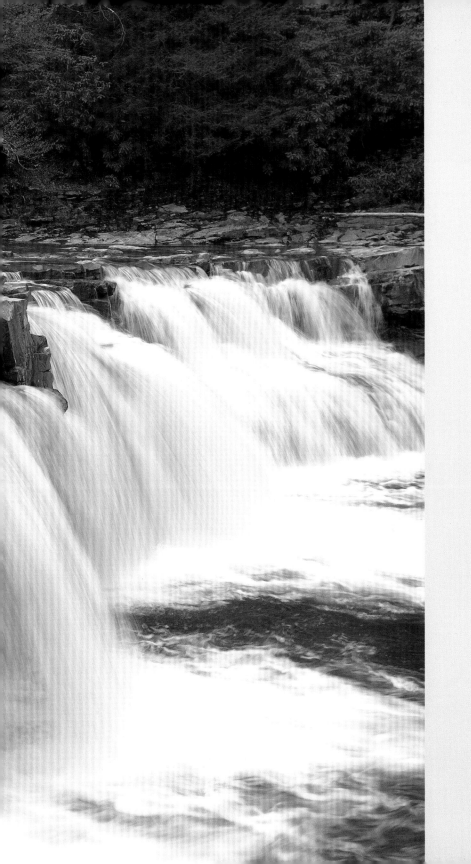

Left: High Falls of the Shavers Fork of the Cheat River,
located in the Monongahela National Forest

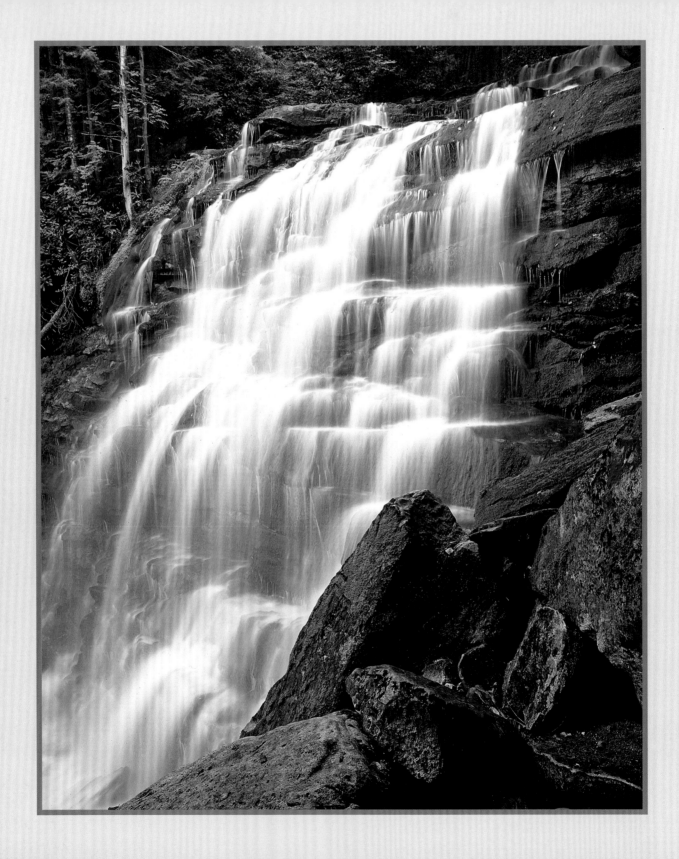

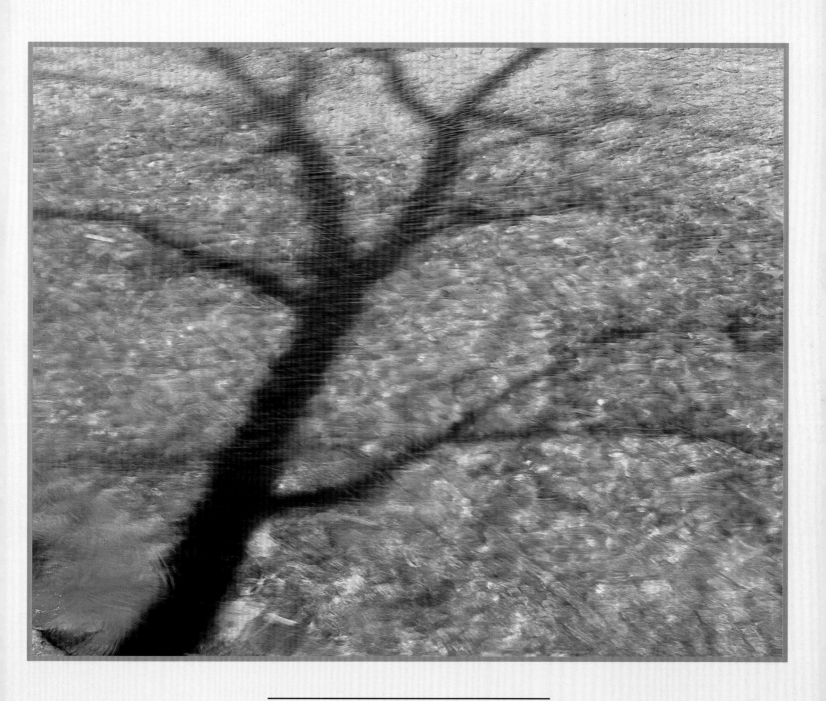

Left: Third Falls on Shay's Run

Above: Shadows on the Potomac River

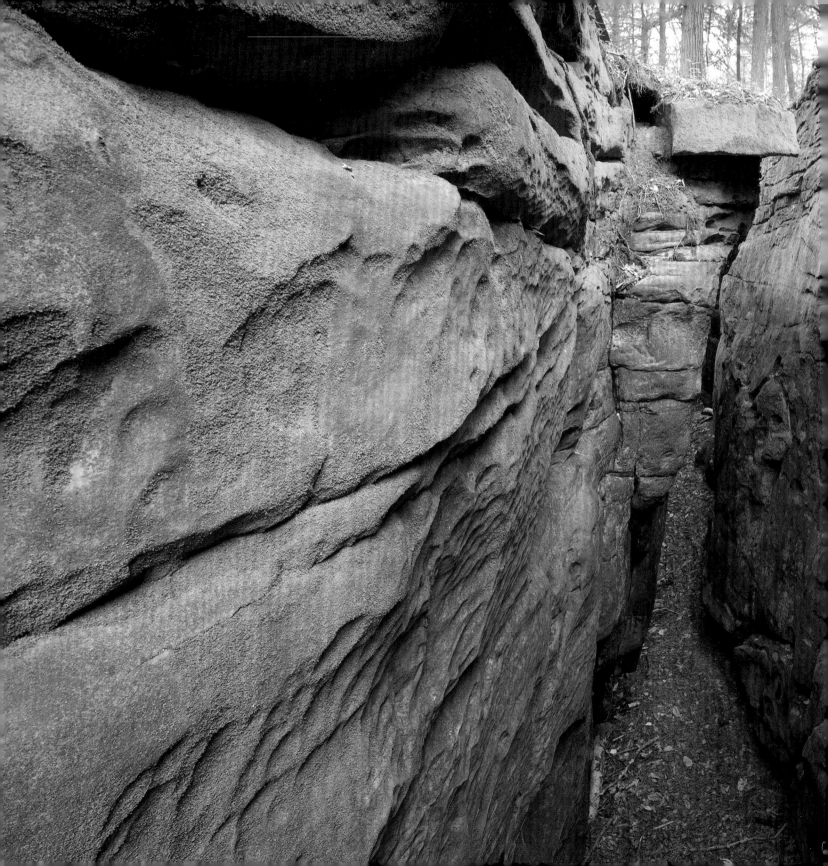

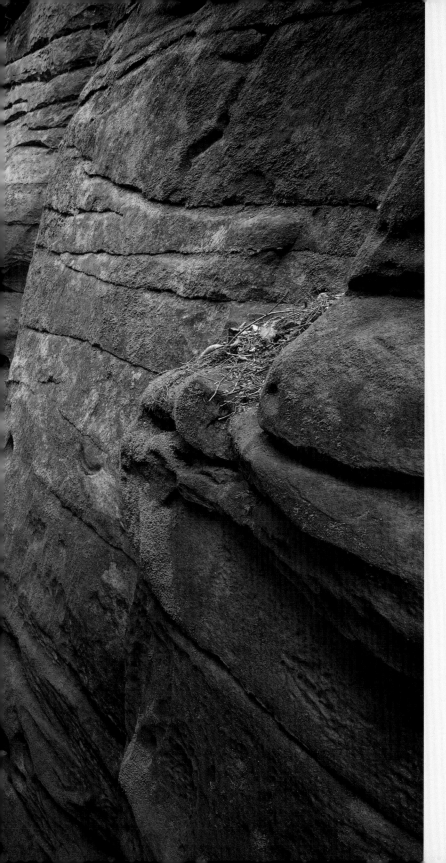

Left: Moss-covered rocks at Beartown State Park inspire the imagination. These unusual rock formations are made of Droop Sandstone and include massive boulders, overhanging cliffs, and deep crevasses.

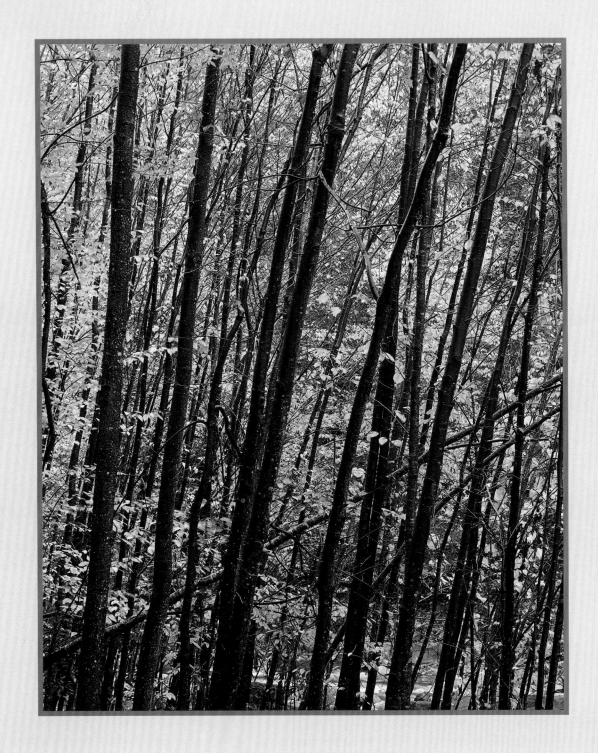

Fall color along Red Creek

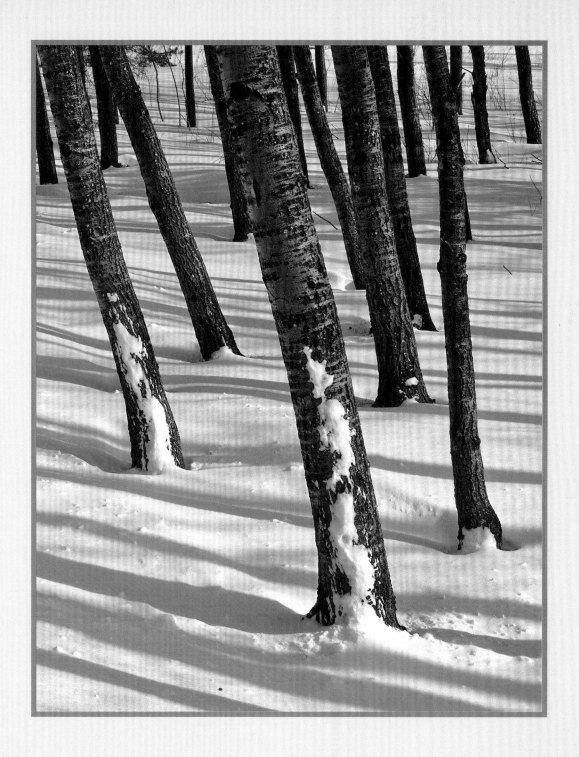

Shadows in snow in Blackwater Falls State Park

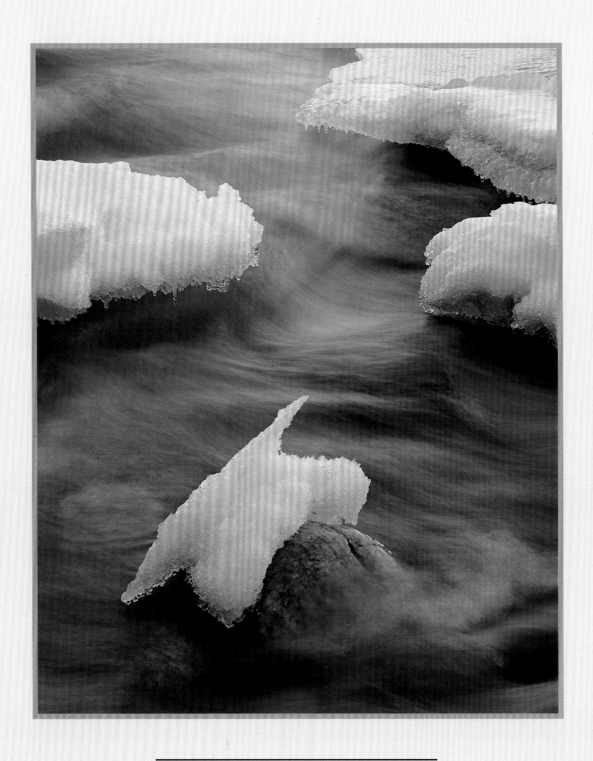

Ice clings to rock on the Potomac River

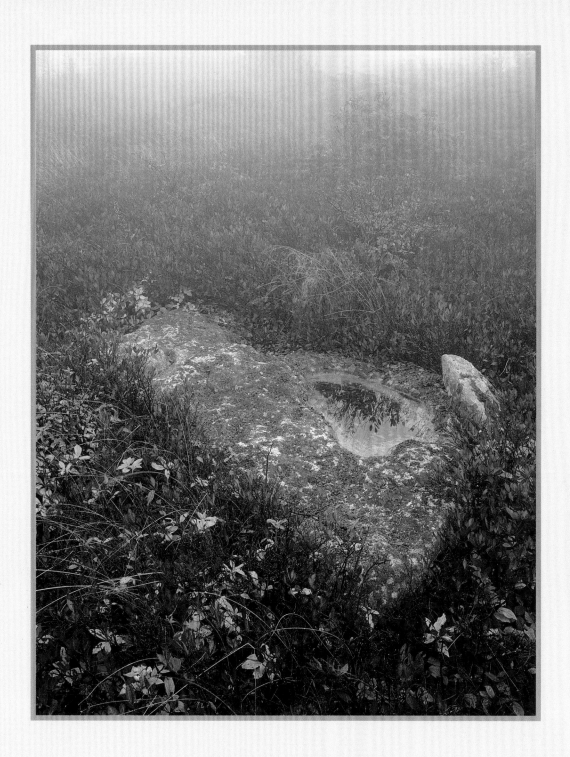

A rock adrift in a sea of autumn crimson

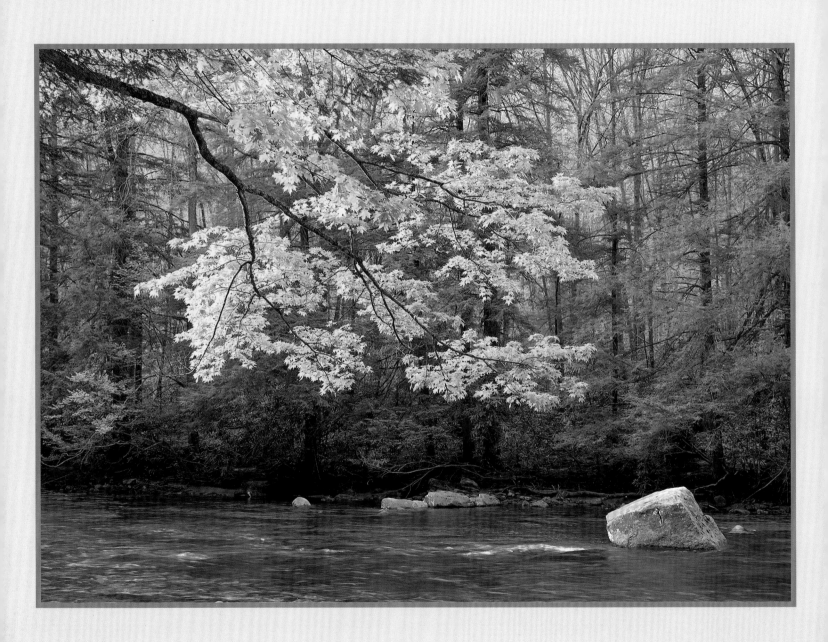

Last light on the Cranberry River

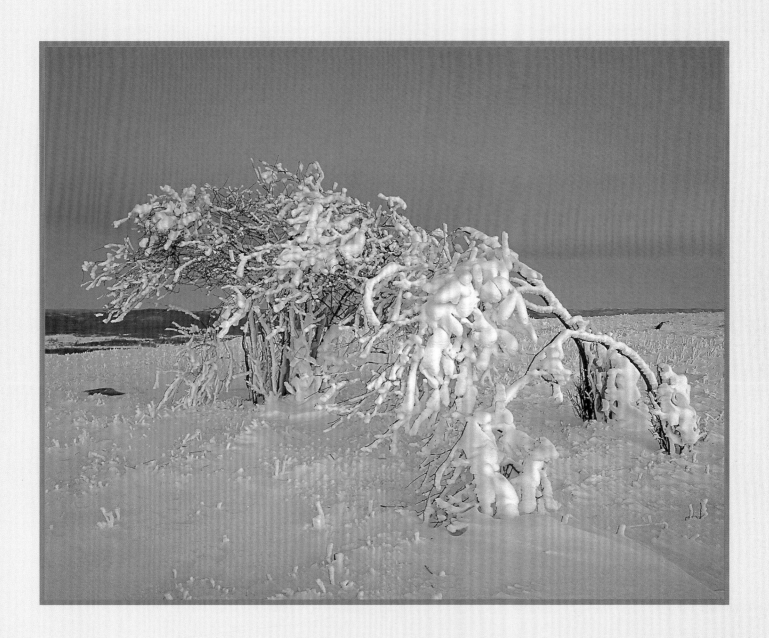

Snow-laden trees on the Allegheny Front

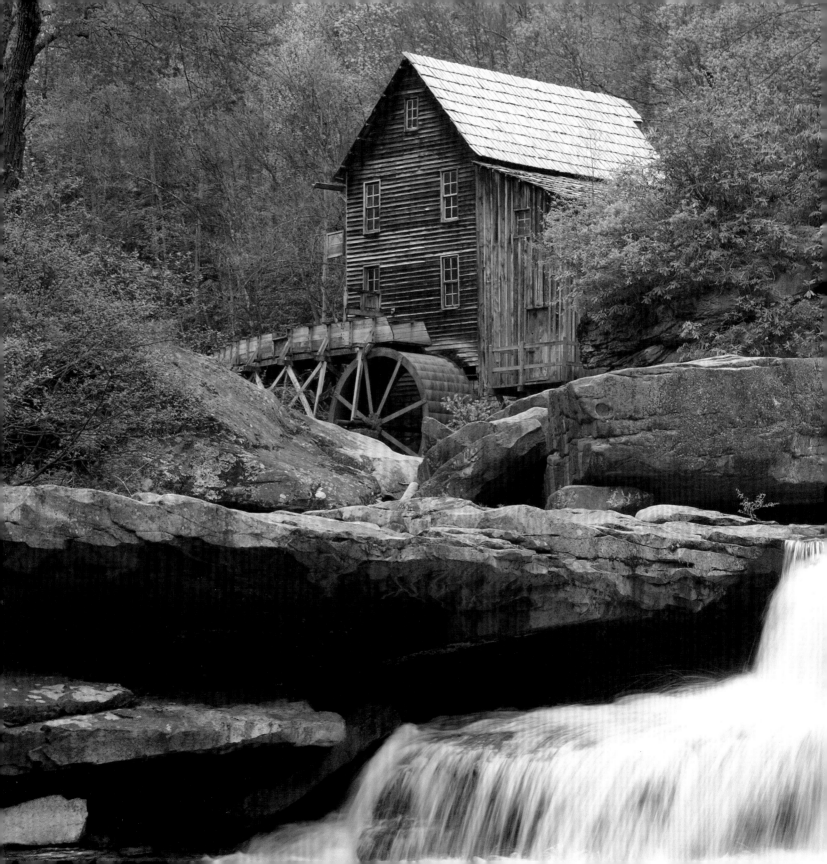

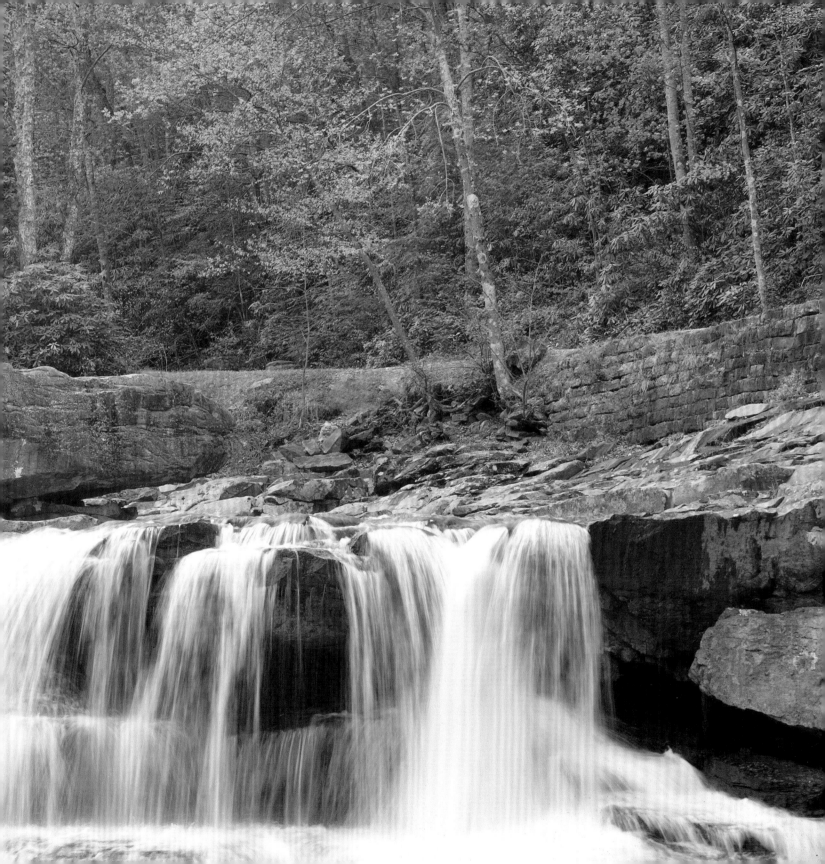

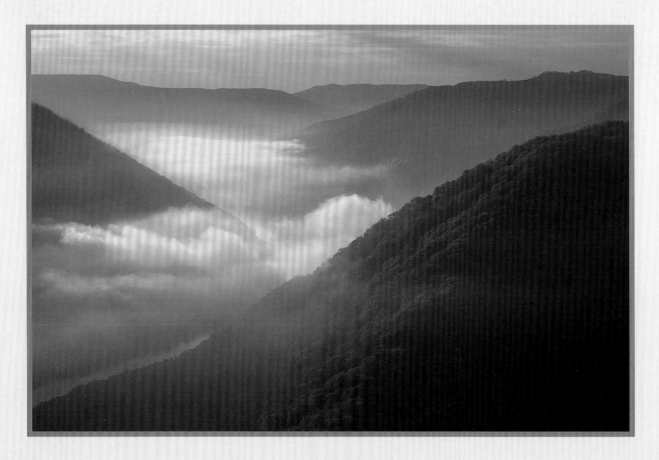

Preceding page: Glade Creek Mill in Babcock State Park

Above: Morning mist in the New River Gorge

Back cover: Above the clouds on Spruce Knob Mountain

About the Photographer: Ian J. Plant has been photographing the Blue Ridge Mountains for the past eight years. Ian lives in Lorton, Virginia with his wife Kristin and their cat Kali.

Other books by Ian J. Plant:
Shenandoah Wonder and Light
Virginia Wonder and Light
Blue Ridge Parkway Wonder and Light

www.ipphotography.com
You can see more of Ian's work on his website, www.ipphotography.com. There you can make on-line purchases of fine art prints of many of the images featured in this book, as well as other images from around the country.